# Complete Guide to
# High Dynamic Range Digital Photography

# Complete Guide to
# High Dynamic Range Digital Photography

Ferrell McCollough

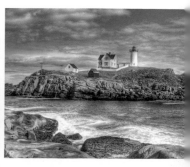

## LARK BOOKS

A Division of Sterling Publishing Co., Inc.
New York / London

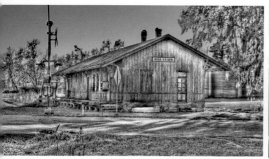

Editor: Haley Pritchard
Art Director: Tom Metcalf
Cover Designer: Thom Gaines

Library of Congress Cataloging-in-Publication Data

McCollough, Ferrell, 1958-
   Complete guide to high dynamic range digital photography / Ferrell
McCollough.
        p. cm.
   Includes index.
   ISBN-13: 978-1-60059-196-9 (PB-trade pbk. : alk. paper)
   ISBN-10: 1-60059-196-5 (PB-trade pbk. : alk. paper)
   1.  Photography—Digital techniques.  I. Title.
   TR267.M3755 2008
   775—dc22

                                2007042186

10 9 8 7

Published by Lark Books, A Division of
Sterling Publishing Co., Inc.
387 Park Avenue South, New York, N.Y. 10016

Distributed in Canada by Sterling Publishing,
c/o Canadian Manda Group, 165 Dufferin Street
Toronto, Ontario, Canada M6K 3H6

Distributed in the United Kingdom by GMC Distribution Services,
Castle Place, 166 High Street, Lewes, East Sussex, England BN7 1XU

Distributed in Australia by Capricorn Link (Australia) Pty Ltd.,
P.O. Box 704, Windsor, NSW 2756 Australia

If you have questions or comments about this book, please contact:
Lark Books
67 Broadway
Asheville, NC 28801
(828) 253-0467

Manufactured in China

ISBN 13: 978-1-60059-196-9

For information about custom editions, special sales, premium and corporate purchases, please contact Sterling Special
Sales Department at 800-805-5489 or specialsales@sterlingpub.com.

## Dedication

I dedicate this book to my wife, Tracy, and my wonderful daughters, Amanda, Kara, and Brooke. Their support and encouragement to follow my dreams has been my foundation.

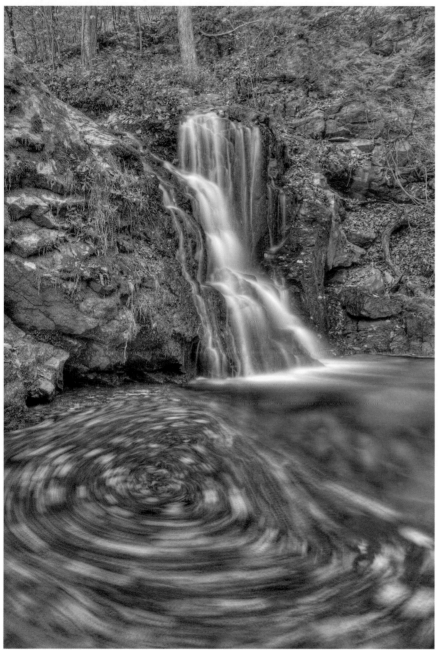

For more information, visit: www.beforethecoffee.com

## Acknowledgements

Thanks to everyone who offered me technical and personal support as I completed this book, especially Hunt's Camera and Video and Nikon. You are all very much appreciated. I also wish to thank contributing artists Trey Ratcliff, Asmundur Thorkelsson, John Adams, Valerio Pandolfi, and Domingo Leiva. They are the forerunners for the next generation of HDR artists.

# contents

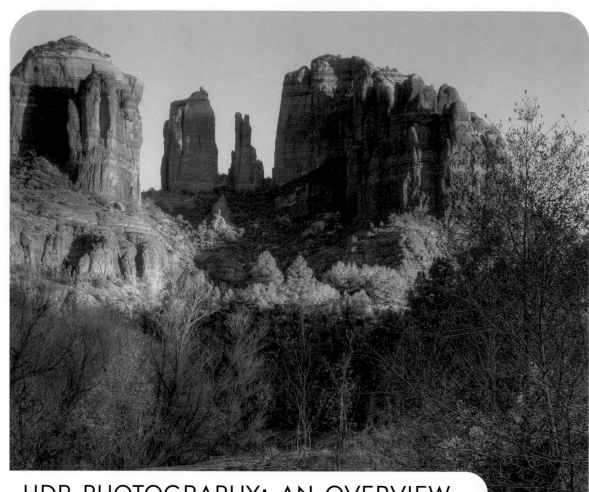

# 1

## HDR PHOTOGRAPHY: AN OVERVIEW

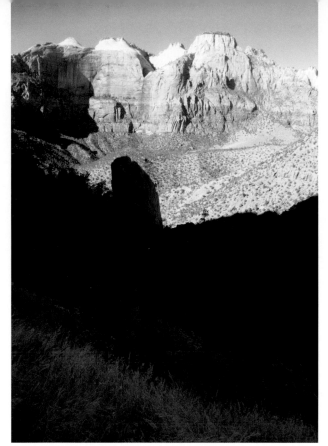

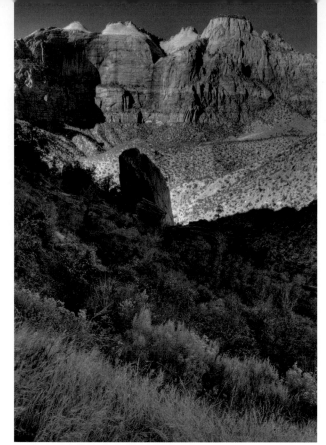

*This is what a high-end digital camera—such as the Nikon D2X I used to make his shot—can do in a single exposure.*

*This is an HDR image processed from 3 exposures taken at –2EV, 0EV, and +2EV.*

High dynamic range (HDR) photography is captivating and mesmerizing, revealing and detailed, utterly awesome, and rich with beauty.

From the early days of film on into the digital era, photographers have been challenged by their camera's inability to record the scene as their eyes see it. Those who were able to master the limitations of the camera learned to "see" as the camera sees and take better pictures. However, for the large population of amateurs and serious hobbyists, many images continued to be a disappointment, with flowers and landscapes lost in murky shadows, and washed out skies that lacked the blue so vividly remembered.

Real world scenery has the potential of displaying enormous ranges of light, and although our visual system is very efficient in adapting to this dynamic range, digital camera sensors, LCD and computer monitors, and print media are not. Now, however, with HDR photography, today's photographers can record images with unparalleled ranges of light.

Dynamic range refers to the variation in luminance from the brightest to the darkest areas of a scene. High dynamic range simply means a wide range of brightness values. HDR photography is the process of taking several pictures of a scene at various exposure levels, then merging the images into one file to maximize the dynamic range of the captured scene.

Each image that contributes to the final HDR photo provides important information about the scene; underexposed images capture highlight detail, and the overexposed images capture shadow detail. The merging process creates a 32-bit file that is capable of holding the full dynamic range of the scene, but it cannot be properly viewed by our monitors or printed by our printers. A second step, called tone mapping, converts the file back to a range we are able to view and print. The final tone-mapped image displays wonderful color and detail in the shadow areas and beautiful, well-exposed highlights.

HDR photography doesn't just happen; it's a workflow that starts before you take the first picture, and it requires knowing how to vary your camera's exposure metering and how many images are needed to capture the full dynamic range of a particular scene. Once the images reach your hard drive you will need to maintain an organized system of file management to keep track of the several images that make up your original files, as well as the combined 32-bit HDR file and the final tone mapped 8- or 16-bit file.

The HDR photography process controls noise in the shadows, captures detail in dark areas, and retains highlights. Is that to say that HDR photography is a perfect medium? Not quite. There are limitations to HDR, as well as conditions where certain HDR techniques are a real challenge. For example, subjects such as kids and pets, regardless of our efforts to get them to sit still, are pretty much guaranteed to display some motion. The result is that, in each image, the subject is recorded in a different spot. When merged to create an HDR photo, the final image has "ghosting," which looks similar to a double exposure. (See pages 115–117 for more information.)

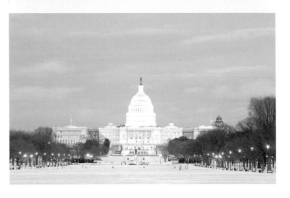

*Here is another HDR image created from 3 exposures taken at –2EV, 0EV, and +2EV.*

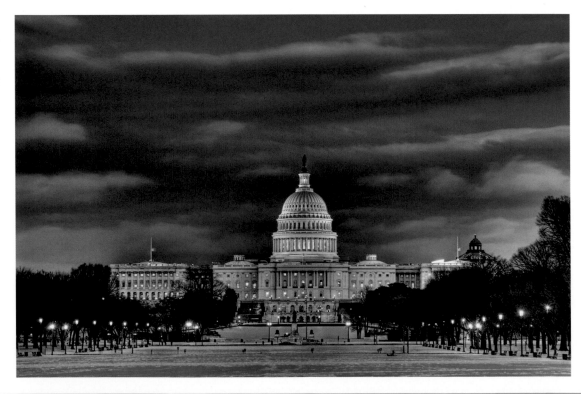

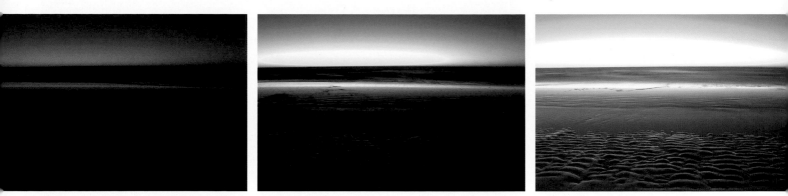

*These three images were taken using exposure bracketing. The first image was underexposed (-2EV), the second was taken at a normal exposure (0EV), and the third was overexposed (+2EV). The 0EV image shows the limited dynamic range capabilities of the digital camera sensor. Pixels along the horizon are saturated, and the details in the sand are limited.*

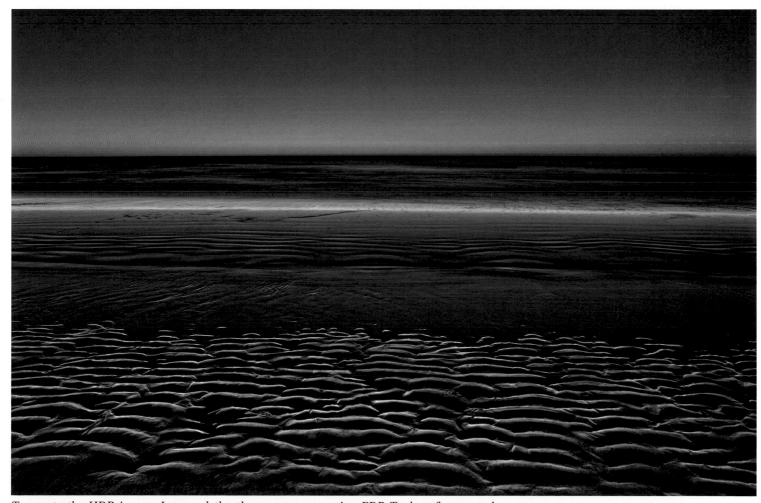

*To create the HDR image, I merged the three exposures using FDR Tools software and tone mapped using the program's Compressor operator.*

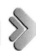

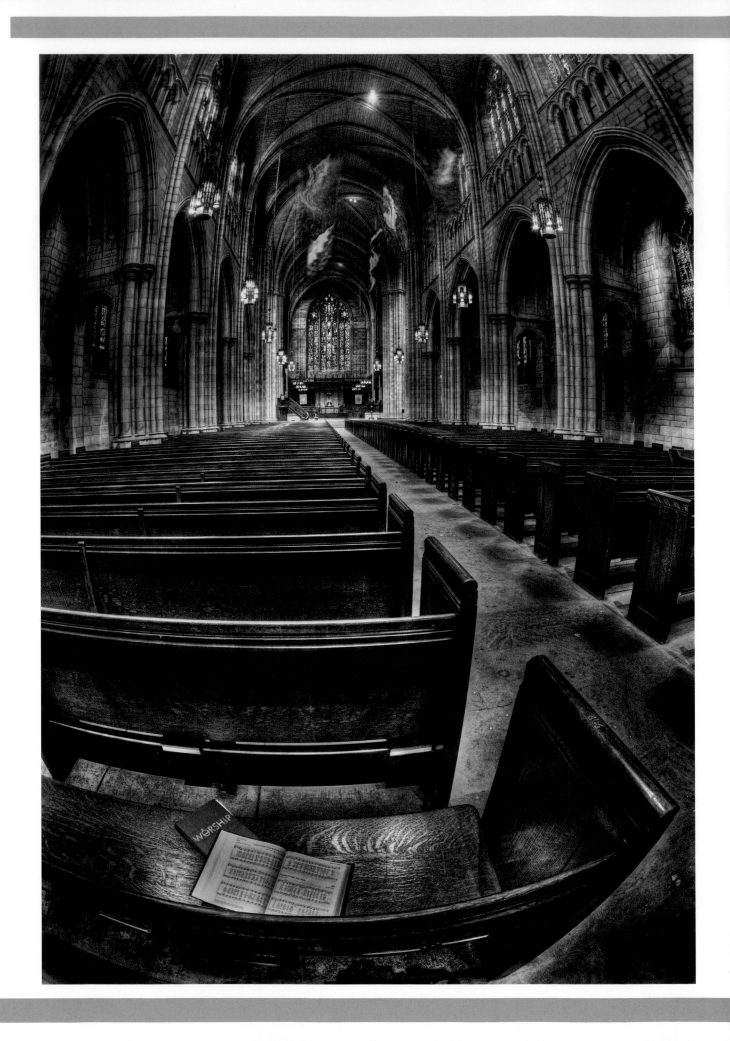

## Measuring Luminance

If you look away from these words for a moment and look at the scene before you, dark shadows and bright areas can be easily noticed. Those shadows and bright areas can be quantified in numbers that represent the luminance of the scene. Even the paper you are looking at has luminance. The standard measure of luminance is in candelas per square meter, or cd/m2. The luminance of a star is about .001 cd/m2, and that of the sun is approximately 1,000,000,000 (one billion) cd/m2.

| Type of Light | Average Luminance (candela/m2) |
| --- | --- |
| Star light | 0.001 |
| Moon light | 0.1 |
| Indoors | 50 |
| Sunny Sky | 100,000 |

# Dynamic Range in the Real World

An average sunlit scene can have a dynamic range of 100,000:1. That means the brightest area is 100,000 times brighter than the darkest shadow. All scenes aren't fixed at this amount; atmospheric haze, cloud cover, and early morning light can cause large fluctuations in dynamic range. Photographers often avoid shooting outdoors at high noon, not only because the light is not warm in color, but also because the contrast ratio between the harsh midday sun and the dark shadows is just too extreme to be visually pleasing. With HDR photography, shooting into the sun is made possible, but don't try to expose for the actual disc of the sun! It's not necessary when the sun is bright and above the horizon.

| Display or Capture Type | Dynamic Range | Stops |
|---|---|---|
| Outdoor Sunlight | 100,000:1 | 17EV |
| Human Eye | 1,000,000:1 | 20EV (long term adaptation) |
| Negative Film | 1000:1-2000:1 | 10EV – 11EV |
| Computer Monitor | 500:1 | 9EV |
| D-SLR | 300:1 | 6 – 8EV |
| High Quality Glossy Print | 200:1 | 7.6EV |
| Compact Digital Camera | 100:1 | 6.6EV |
| Average Quality Glossy Print | 100:1 | 6.6EV |
| Slide Film | 64:1 | 6EV |
| High Quality Matte Print | 50:1 | 5.6EV |

Exposure Value (EV) is an integer that corresponds to scene luminance such that EV = 0 when the correct exposure is 1 second at f/1.0. An EV increment of one (1EV) is the same as a "stop" and refers to half as much or double the amount of light. The greater the exposure value, the greater the luminance of the scene.

Outdoor light can have an exposure value of as much as 17, and our eyes can see exposure values up to about 20EV when given the time to adjust to the light level. Digital cameras, monitors, and print media fall well below the capabilities of what can be seen in the real world, only capturing and displaying as little as 5 – 10EV. Therein lies the problem: How do we capture and display scenes with higher exposure values than present technology is capable of rendering?

# Digital Camera Sensors

The majority of digital cameras have what is known as a Bayer Pattern sensor. The sensor consists of an arrangement of pixels that are sensitive to the colors red, green, and blue. Since our eyes are more sensitive to green, sensor designers included two green pixels for each red and blue. Once the signal is received, the final color and intensity of each pixel is determined through Bayer interpolation.

Many digital cameras, especially D-SLRs, support a RAW format for image capture (such as Canon's proprietary CRW and CR2 files, or Nikon's NEF files). A single RAW image can record about 10EV, which is good, but still falls short of capturing the full dynamic range of many scenes. As a result, some users have dubbed the RAW image as medium dynamic range (MDR).

When your camera is set to store images as JPEG files, the image data goes through Bayer interpolation followed by a stage of processing for in-camera parameters such as white balance, saturation, sharpness, contrast, etc. In the last step, JPEG compression is performed and the file is stored. The final processed JPEG has been cut down to 8-bit data with 256 different intensity levels, capturing only about 8EV, and can be referred to as a low dynamic range (LDR) image.

*The diagram above illustrates the pattern of red, green, and blue pixels used in Bayer Pattern digital camera sensors.*

# How HDR and Larger Pixels Help Beat Noise

The spoiler of dynamic range is noise. At the dark end of the scale where pixel brightness values approach zero, the noise gremlins hold their ground. At the bright end of the scale, around brightness values of 255, pixels become stressed, resulting in color shifts and blooming. Color shifts are the result of the R, G, and B channels (red, green, and blue) being clipped at different points of saturation until eventually the pixels give up and become "blown" or white. Blooming occurs when more photons fall onto the pixel than it can hold, causing photons to spill over to the adjoining pixels until they are full. The process results in blown areas and goes on until the shutter is closed.

The job of the camera sensor is to convert photons of light into electrons. Any instrument that uses circuitry to move electrons will have noise associated with it. Noise is simply bad information that becomes part of the actual signal and destroys the quality of the signal, much like a mom and dad having a conversation might turn to their teenager and say, "Turn that noise down!" Why? The noise is overwhelming the quality of the signal. Noise in the camera sensor is there and will always be there; it pertains to the laws of physics. However, you can get ahead of the noise issue by using HDR digital photography to gather the full gamut of well-exposed image information from the scene.

Digital camera sensor designers have wisely moved towards making the pixels that gather the photons of light a little bit larger. The larger the pixels, the more photons they can gather in a given time interval, thus making noise a smaller piece of the pie. As in most areas of technology, the more we spend on a particular product the better the quality. The added quality for digital sensors comes in the form of larger pixels and more of them. D-SLR pixels range in size from 5 – 9 microns, and the pixel size within compact digital camera sensors ranges from 2 – 3 microns. D-SLRs not only have larger pixels to gather photons with, but they usually have more of them.

Let's go back to our discussion of how noise is mainly present in the dark shadow areas of an image. The reason for this is the lack of photons, or insufficient light to overwhelm the noise. So, it follows that overexposing an image allows more photons to be captured, thus reducing the noise. This is one of the main arguments for HDR photography; the overexposed image provides good shadow detail and allows for merging of quality pixels with reduced noise.

At the brighter end of the exposure spectrum, we find blooming and slight color shifts. Once these pixels are blown, the information is irrecoverable. In the creation of an HDR image set, the underexposed image captures the highlight detail by closing the shutter before the pixels become blown. Then, in the merging process, these quality pixels are brought together to create the final image. In this way, HDR photography is able to overcome the shortcomings of the digital sensor in the area of noise and blown pixels. (For additional information on camera sensor dynamic range and noise levels, visit www.imatest.com and www.clarkvision.com.)

# A Little "Bit" Goes a Long Way

In 1989, Greg Ward (www.anyhere.com) began using real world luminance values to light computer generated objects, and he created the .hdr file format to accommodate large data needs. Over the next decade, HDR imaging grew by leaps and bounds and became a leading method for lighting computer generated images in the world of major motion pictures. Today's digital cameras allow us to take this exciting technology and create brilliant HDR images ourselves.

## JPEG and TIFF

The two standard file formats for saving images after RAW conversion are JPEG and TIFF. (When you record your digital files as JPEGs in-camera, your camera actually captures each one as a RAW file and uses its proprietary technology to convert to JPEG.) The 8-bit JPEG format holds luminance values that range from 0 – 255, while the 16-bit TIFF format holds luminance values that range from 0 – 65,535. As you can see, the 16-bit TIFF format holds a much wider range of luminance values than the JPEG format.

## HDR

High dynamic range images are stored using several file names, the most popular being the RadianceRGBE (.hdr) and OpenEXR (.exr) formats. The RadianceRGBE format is a 32-bit format and the OpenEXR starts out at 48 bits and is then reduced to 32 bits during processing. These file formats are lossless; saving and reopening the files does not cause any data loss.

The HDR format is able to express luminance over a much wider range than other file formats, and can attain what are known as floating point luminance values. These floating point values allow nearly infinite brightness ranges to be described. With HDR, the pot is never full. It has the capacity to represent the full range of luminance in the scene. In fact, the capabilities of the HDR formats far exceed our needs as photographers shooting in the natural world.

8-bit images
- Low dynamic range
  - Luminance values of 0 – 255

16-bit images
- Medium dynamic range
  - Luminance values of 0 – 65,535

32-bit images
- High dynamic range
  - Floating point (unlimited) luminance values

The RadianceRGBE (.hdr) format is known for its ability to represent 76 orders of magnitude in dynamic range that far exceeds our real world luminance range. This format spans more dynamic range than photographers would ever need, though its precision is slightly less accurate than its OpenEXR (.exr) format counterpart.

## Floating Point Luminance Values

To better understand floating point values in comparison to the limitations of 8- and 16-bit luminance value capabilities, think of a musician playing a guitar. If he or she were confined to playing within the center six frets of the guitar, the sound produced would be limited to the notes within those frets. If they wanted to play one of your favorite songs but many of the notes fell outside of the allowed frets, they wouldn't be able to offer a very good rendition of that song. This kind of limitation parallels the limitations of the 8-bit JPEG file.

Extend the boundary of the guitarist's fret limitations by three frets in each direction and things start to sound a little better; not perfect, but better. This represents the 16-bit capabilities of the TIFF file. Now let's take away all restrictions, even the frets themselves. Not only does the guitarist have the full range of notes available, but removing the frets allows a continuum of any sound within the full range of the instrument. This represents the HDR 32-bit format. The extended, practically limitless possibilities for tonal values that the fretless instrument offers represent the floating point luminance values of the HDR format.

So, can good music come from six frets? Sure it can, just like good images can come from 8-bit JPEGs. It all comes down to the dynamic range of the scene and how much of that range falls within the capabilities of the format doing the capturing.

A common misconception is that converting a single RAW, TIFF, or JPEG image into a 32-bit HDR file will create a high dynamic range image. You can make the conversion, but it doesn't magically create a greater dynamic range than the file already contains. The process will not add details in the shadows that weren't there already, or recreate highlights that were blown. Converting a single image to HDR is analogous to moving ten apples to a larger basket; you still only have ten apples.

## HDR vs. RAW for Image Archiving

Many people wonder whether HDR images can or should be used as digital "negatives" for archival purposes. They contain all the light of the scene, so it seems like it would be the ideal format to use for image preservation as technology improves. In theory, this makes sense. In practice, however, we find that merging your RAW source images into one HDR file will give different results depending on the program doing the merging. Each program has its own proprietary merging algorithm, and these vary in how they choose the final luminosity of a pixel based on a stack of three pixels (from three source images).

Let's say you have an almost black pixel, an almost white pixel, and a gray pixel. One program may average all three pixels while another throws out the white pixel and averages the gray and black. The merging algorithms have different working thresholds and

all give a different result. Not only is there a difference between programs, but there is also a difference between versions of the same program. In addition, image alignment and ghosting removal technologies will certainly improve in years to come.

So, the better choice is to archive your RAW source images. However, even the longevity of RAW files is not guaranteed. Camera manufacturers continue to develop new RAW formats, and many new conversion programs don't include options for older RAW file format conversion. I recommend that you stay informed about trends in the use of Adobe's Digital Negative as a container for all converted RAW files.

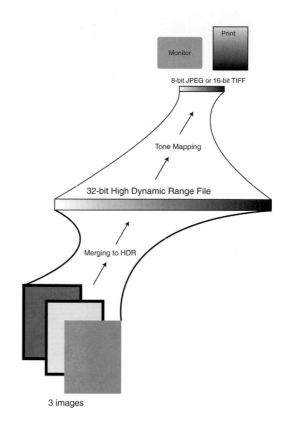

*The HDR workflow begins with the merging of various exposures into one 32-bit HDR file. After merging the images, tone mapping must be done to scale the file back down to a dynamic range we can view and print.*

# Tone Mapping

Tone mapping is the process of scaling back a 32-bit HDR file from a high dynamic range that contains real world luminance information to a lower dynamic range that can be displayed by our monitors and printed on our printers. Remember, real world luminance can have a range of more than 100,000:1 (that's 100,000 times brighter than the darkest shadow), but our monitors can only display about 500:1. The process of dynamic range reduction changes the file from having 32-bit floating point values to having 8-bit or 16-bit integer values.

## How do HDR and RAW Images Differ?

Recall that a single RAW image can capture about 10EV in dynamic range, which is not always sufficient. If we look at the histogram of a single RAW exposure and compare it to the histogram of an HDR image, we can quickly see the difference. Black pixels on the left side of the histogram and white pixels on the right of the histogram is adequate proof that the full dynamic range of the scene was not captured.

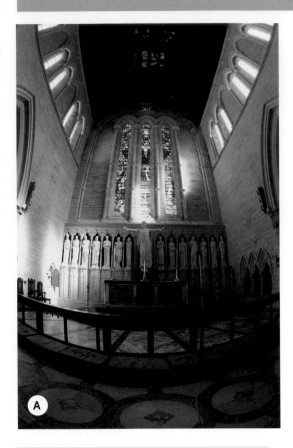

A

histogram for image A (B) shows blown pixels on the right and black pixels on the left. It is a high-contrast scene that is beyond the sensor's ability to capture. The blown pixels in the shafts of light across the altar cannot be recovered, and the pixels in the shadow areas of the ceiling are dark and lack sufficient detail.

Now look at the histogram for image C (D), the HDR image. It has a nice shape with a good collection of pixels in the midtones and, more importantly, blown pixels and black pixels are not gathered at the left and right sides of the graph. The HDR image has a tonal

B

In image A (above), light is beaming across the altar from the upper window. This is the "normal" exposure—a RAW file with zero exposure adjustments. Image C (right) illustrates the merging of five images taken with one stop of light difference (1EV) between each; they were combined and processed using the FDRTools software program. The

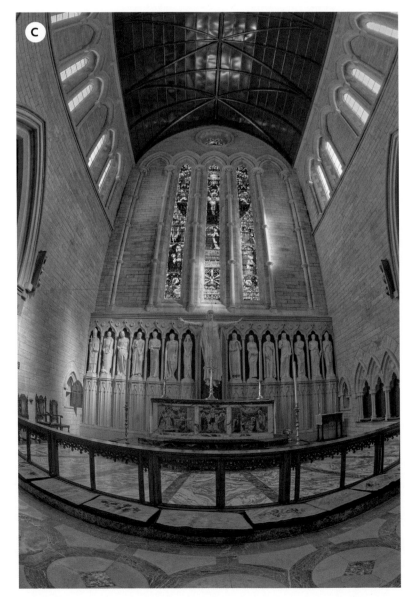

C

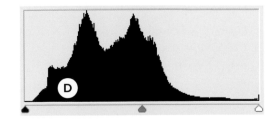

D

range that is nicely within the boundaries of the black shadows and white highlights. When we compare the two histograms we can see how the tone mapping process has redistributed the pixels along the histogram.

## The Necessity of Tone Mapping

When the 32-bit HDR file is displayed on a low dynamic range monitor, it immediately becomes apparent that significant areas are displayed as black pixels or blown white pixels (E). The "lost" pixels represent luminosity that is beyond the range of the monitor. After tone mapping, the same monitor has no problem displaying the details throughout the image (F). The highlights in the sky are not blown and the details in the cliffs are noise-free and well-exposed.

Manufacturers are beginning to realize that creating better tools for working with and displaying HDR images is the way to go. A company called Brightside Technologies introduced the first HDR display, which uses individually modulated LED backlight technology to increase the brightness and deliver 100 times the brightness and contrast range of any existing CRT, plasma, DLP, or LCD television or computer monitor.

The "increased brightness" of an HDR display doesn't mean it's painful to look at it. To the contrary, the images are simply more vibrant and lifelike. And turning up the brightness on your existing monitor won't do the trick.

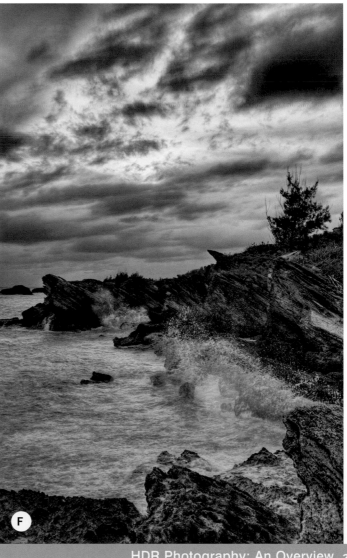

*I created this HDR image by taking five separate exposures at 1EV spacing (one stop) from each other.*

Can you tone map 8-bit and 16-bit images? The answer is yes; single image tone mapping is possible, and it is a popular method to enhance shadow detail in low dynamic range images. (See pages 142—157 for more information.) Be careful though; if the image has a lot of noise, the noise can become enhanced by tone mapping.

Not only is tone mapping needed for viewing the image, it is also necessary if you want to print an HDR 32-bit image file. The dynamic range of the reflective print is limited by ambient light and absorption of light, and has inherently low dynamic range. Even when HDR display monitors become mainstream, tone mapping HDR files will still be necessary when the final output is a traditional print.

## Tone Mapping Operators

Tone mapping operators vary widely but, for simplification, there are two main classes of operators: global and local. Both are designed to compress high dynamic range scene information to a dynamic range that can be viewed on monitors or printed out.

Global operators are simple, mathematical algorithms that apply the same compression to all the pixels in the image. They typically have fast processing times but receive few accolades simply because the images lack visual impact. Photomatix Pro has a global operator called Tone Compressor, and

FDRTools has two, Simplex and Receptor. As we will show later, global operators have their place in the photographic world and shouldn't be so quickly dismissed. They can provide a feel of realism to the image that local operators often exaggerate.

To understand a global operator, think of a metal spring that has to be compressed to fit in a box. The spring is the 32-bit HDR file and the box is your monitor. The global operator would compress the spring evenly from both sides to fit it into the box. Nothing fancy; it carries out compression such that all pixels are evenly compressed to meet the limitations of the box.

Local operators are advanced algorithms that look at a pixel and compare it to a neighborhood of surrounding pixels. Two identical pixels, one surrounded by brightness and the other surrounded by darkness, will be compressed differently. As a result, the local operators have longer processing times but are more effective in dealing with high dynamic range images.

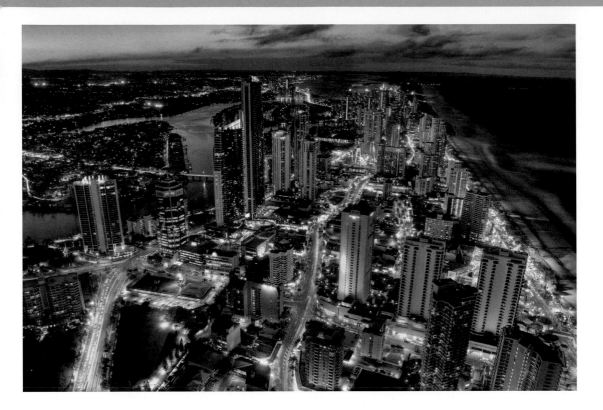

The local operator used in the Photomatix Pro software program is called Details Enhancer; in FDRTools it's called Compressor. Each local operator has adjustment sliders that control how much a pixel is compressed and the size of the neighborhood of pixels that is sampled. The sliders (i.e., Compression, Micro-contrast, Strength, Radius, etc.) allow you to enhance local contrast and improve details in regions that would otherwise be lacking.

Recall our analogy of fitting a spring in a box. Instead of the linear compression that a global operator performs, which is uniform throughout, a local operator will vary compression along the entire surface of the spring to fit it snugly in the box. For example, a local operator algorithm might compress highlight areas to allow the midtones and shadows to expand into the available space. Additional control with the adjustment sliders allows you to vary the intensity and location of the compression to achieve the desired effect.

*Global operators apply even compression to the 32-bit image.*

*Local operators use complex algorithms to vary the compression of the 32-bit image.*

## After Tone Mapping

A common feature of tone mapping (and often a criticism of the tone mapping process) is the global reduction of contrast. It is important to understand that, when tone mapping, the position of the sliders can create tonal relationships that become skewed enough to violate what we think is correct. Areas in the image that we recall as darker now appear brighter. Tonal boundaries can be crossed, and scenes can begin to look cartoon-like. This extreme type of tone mapping can be quite artistic but it can also be gaudy. This effect can be offset by local contrast enhancements that increase the perceived contrast of the entire image.

*This image illustrates extreme tone mapping that has caused halos where the sky meets the other scene elements.*

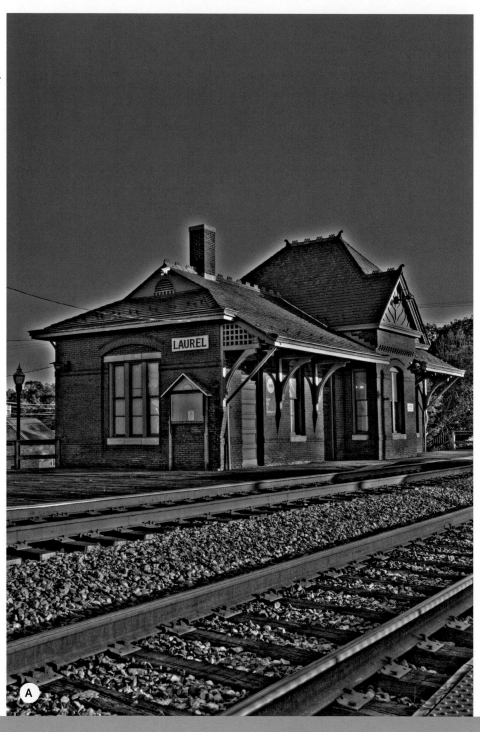

A

Local contrast enhancements make it all come together. By "local," I mean small-scale, like between the bricks of a building or along the edges of leaves in a tree. If the image has an abrupt line of contrast, the tone mapping process enhances it and grabs your attention. Each line of contrast has been emphasized but only over a limited distance; this is local contrast enhancement. In example A, the extreme compression is evident where strong halos have developed along the roofline of the building. Halos are common where subjects such as trees, power lines, and buildings extend into a blue sky. (See page 56 for more about halos.)

Hint: Fortunately, halos can be controlled with several sliders or smoothing functions that ease the transition of local contrast over a greater distance (B). However, some people see halos as an exciting image element that ads drama to the scene. Others are less inspired. I'm of the latter group; I find halos a little too unrealistic. They often look like an odd form of over-sharpening.

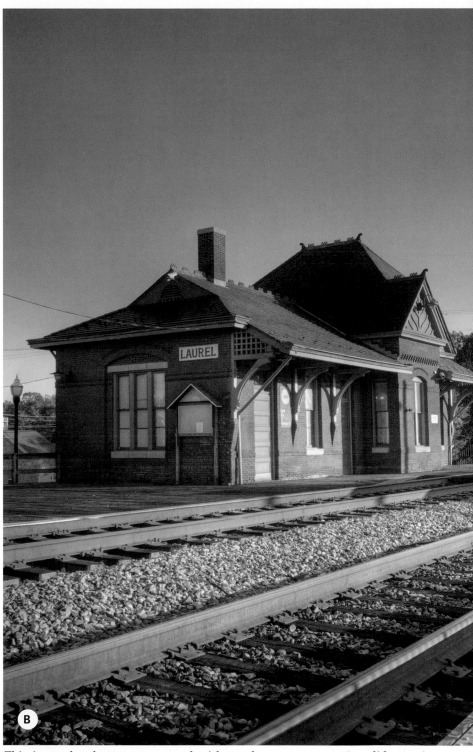

*This image has been tone mapped with much more conservative slider positions. There is still a reduction in global contrast, but the halos that were apparent have now been smoothed over a larger region.*

# Trey Ratcliff

**Artist Statement:** My background is in computer science, math, and design. As a game designer, I tend to look at the world in both a digital and an artistic way. People consume art as a form of escapism, and it's proven that people tend to enjoy escaping into somewhat stylized environments because it allows them to overlay their own emotional context and make it more personal.

In my judgment, a well-executed HDR image evokes the essence of the original scene. When a human eye is actually on location, it is constantly moving, adjusting the pupil size, allowing in more light in some areas and less in others, and the visual cortex actually works to merge these observations into an overall vision of the scene. That is what we remember in our mind's eye: an idealized, super-realistic version of the scene. HDR digital photography is the perfect medium to translate this super-realism into an image.

Visit http://stuckincustoms.com/ for more of Trey Ratcliff's stunning HDR imagery, or http://www.treyratcliff.com to learn more about the artist.

stuckincustoms.com / www.treyratcliff.com

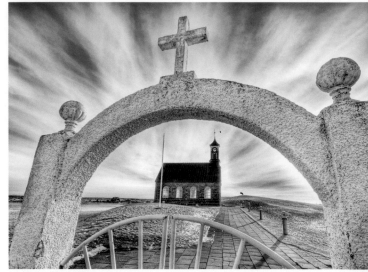

© Trey Ratcliff

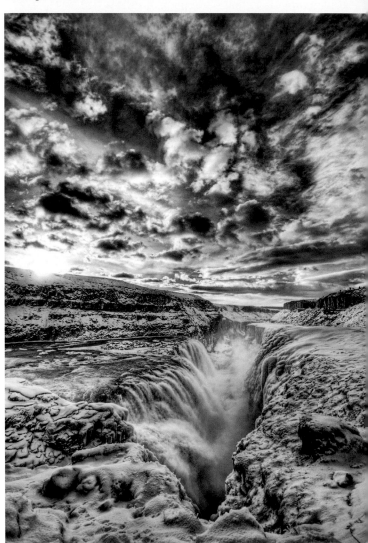

© Trey Ratcliff

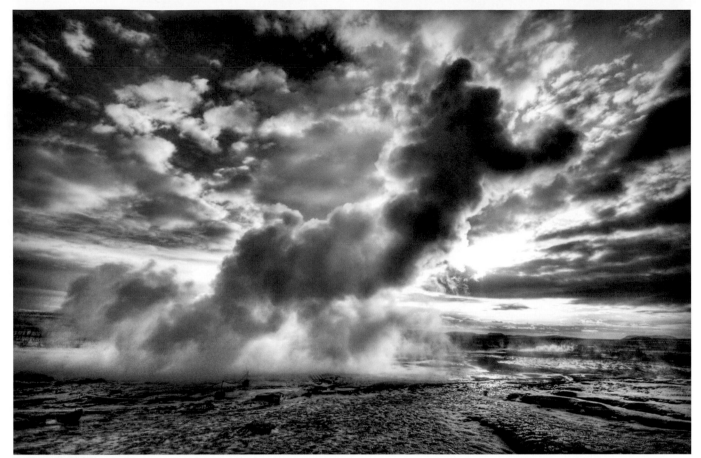

© Trey Ratcliff

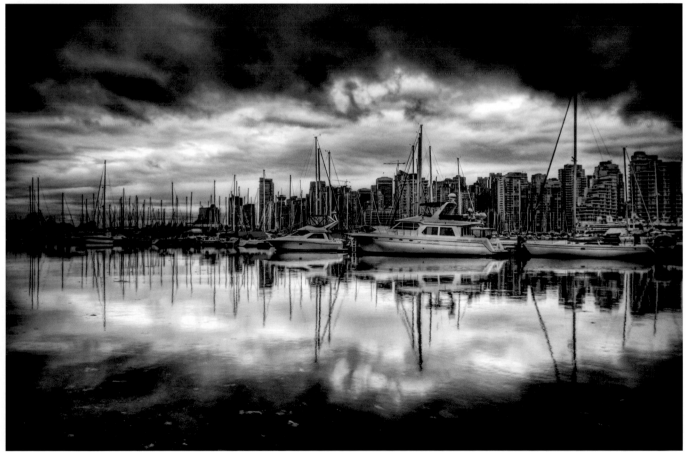

© Trey Ratcliff

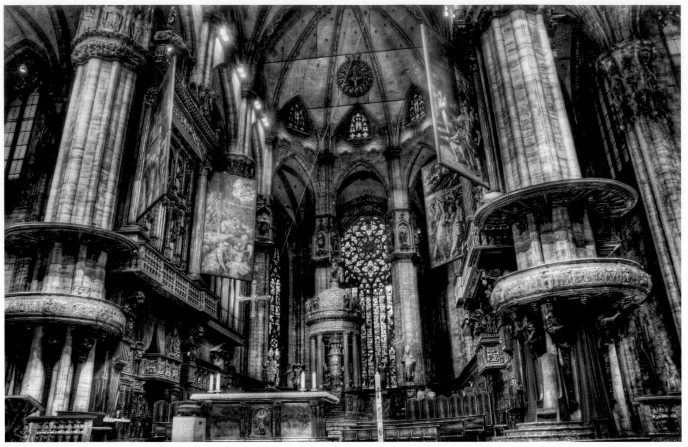

© Trey Ratcliff

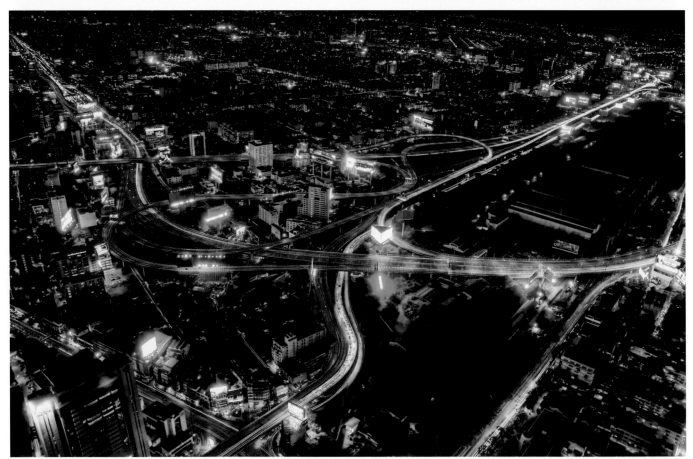

© Trey Ratcliff

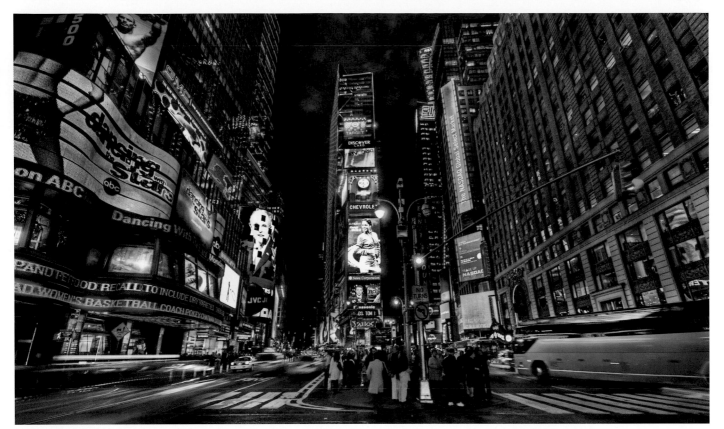

© Trey Ratcliff

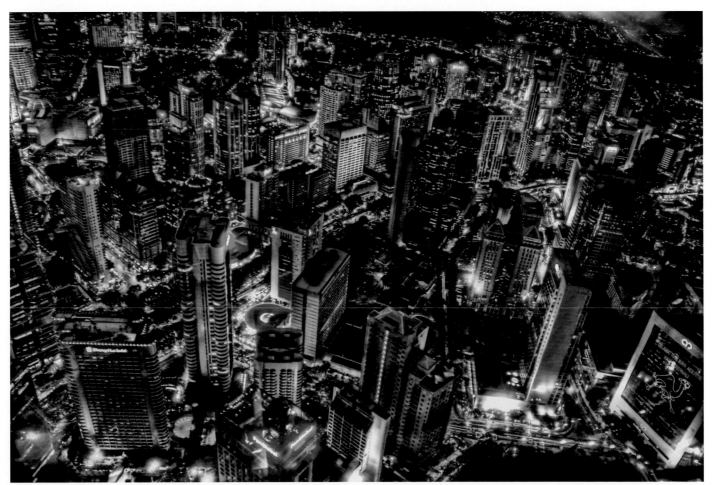

© Trey Ratcliff

# 2

## EQUIPMENT, CONRTOLS, AND TECHNIQUE

# Point-and-Shoot Digital Cameras

Two photographers jump out of bed and leave for an entire day of shooting. One photographer has the best D-SLR on the market but uses poor photographic technique. The other photographer has a mid-grade D-SLR but really knows the camera and uses good photographic technique. Who do you think will have the better images? I'd put my money on the photographer with good technique in almost every situation. You will become a better photographer by knowing all the functions of your camera and practicing good technique, not simply by accumulating the best equipment.

The great thing about HDR is that you don't need lots of expensive equipment to create these striking images. If you are looking for the bare necessities to get started, an inexpensive point-and-shoot digital camera will do as long as it can use exposure compensation. You will also need a decent tripod so that the camera is steady and each image is registered in the same position. Point-and-shoot digital cameras often don't offer RAW file capture, but don't worry; JPEGs still work very well for merging to HDR.

Shooting handheld with a point-and-shoot digital camera is possible only if the camera has an auto exposure bracketing feature (AEB). When set to AEB, several images at different exposures can be taken at one time.

When using autofocus, you lightly press the shutter release button and the camera searches for a focus point, but if focus changes from one image to the next, you may run into a problem when you try to merge the images. The first image might be focused on the edge of the tree, and the second image could be focused on the bridge in the background. The best way to avoid changing focus points is to move back from nearby subjects, or simply switch to manual focus if your point-and-shoot digital camera allows.

## Digital Point-and-Shoot Quick Tips

Once you establish a workflow, you can create HDR image sets with very little effort. Don't get too bogged down over the camera's ability to do the job perfectly; after all, it is a point-and-shoot camera. When in doubt, just go for the shot and you'll most likely get something you really like. All you need to do is follow these simple steps:

1. Mount the camera on tripod.

2. Turn off automatic settings such as flash, white balance, autofocus, and ISO.

3. Shoot in Aperture-Priority mode to keep the aperture fixed.

4. Compose and shoot image one.

5. Change your exposure to +2 and shoot image two.

6. Change your exposure to –2 and shoot image three.

7. Don't forget to change the exposure compensation back to 0.

If your camera does not have an AEB feature, you will have to use a tripod. Otherwise, trying to fumble with dials and buttons between each image will cause excessive misalignment, and the merging software may not be able to realign the images.

Another important tip when shooting HDR images with a point-and-shoot digital camera is to take the white balance and ISO settings off of Auto mode. Switch your white balance to the most appropriate pre-programmed setting and shoot at the lowest ISO possible for the amount of light in the scene. You will also need to turn off your flash when shooting because the camera needs to expose for ambient light. (This may require disabling the automatic flash function, if your camera has one.)

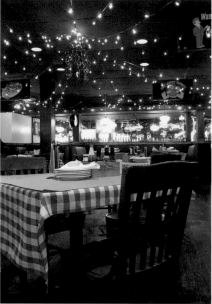

# Digital SLR Cameras

The digital SLRs (D-SLRs) of today have many functions that allow for a variety of shooting techniques. Manual exposure mode works well for full control of each exposure, but auto exposure bracketing (AEB) can automate the process and eliminate the need to adjust the camera for each shot. The only essential rule is that focus, white balance, ISO, and aperture remain the same; only shutter speed can change from one exposure to the next so shoot in Aperture-Priority mode (or Manual exposure mode) to ensure that the aperture doesn't change. Automatic features that you may have set (such as focus, flash, white balance, or ISO) will need to be turned off or adjusted appropriately so as not to access the automatic setting during picture taking.

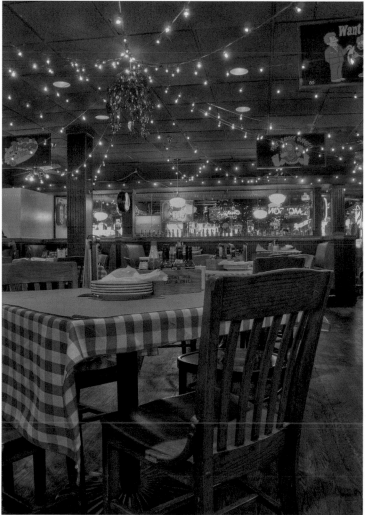

*What else is there to do while you're waiting for your burger? I placed the camera on the table and held it securely while I changed the exposure compensation. This HDR image is from merging three images at 1EV spacing in Photomatix Pro software.*

# RAW vs. JPEG

In the world of digital photography today, we are bombarded with information that RAW is superior to JPEG and that all of our photography should be captured using RAW. It may be true with single image digital photography, but as far as HDR digital photography goes, the JPEG image can be every "bit" as good as the RAW file. It doesn't matter if 8-bit or 12-bit does the capturing, as long as the full dynamic range is captured. In other words, if you have a camera that records only in JPEG, I don't recommend buying a new camera just for capturing HDR image sets in RAW.

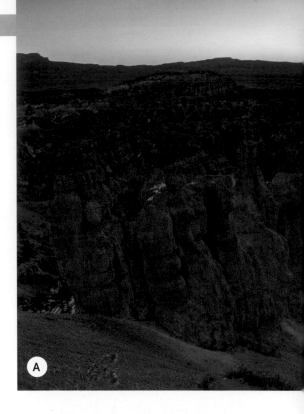

## Using JPEG for Digital HDR Imaging

This is Bryce Canyon, where I pointed the camera directly into the sun and composed a high contrast scene (A). In addition to lens flare, metering problems, and focusing problems, the camera could not begin to capture the high dynamic range in a single exposure. So, I took seven JPEGs at 1EV spacing and merged them into an HDR image (D). When looking at a close-up it becomes clear that the HDR image (E) created from seven JPEGs has good detail and color accuracy, while the single JPEG (B) has noise and color shifts in the tree. The histogram for the single JPEG (C) indicates a scene that is well beyond the dynamic range of the camera sensor. However, notice how the histogram of the HDR image (F) has well-developed midtones with the highlights under control and limited black shadows.

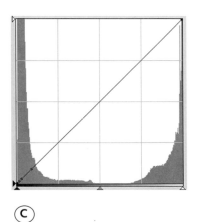

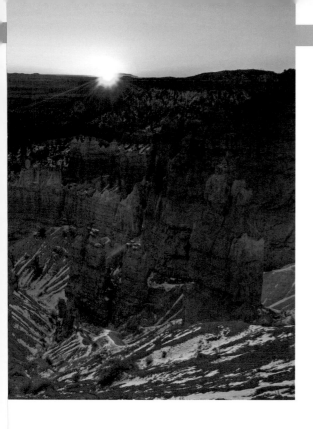

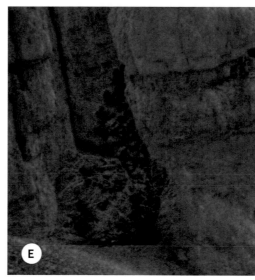

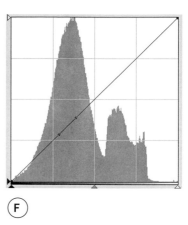

F

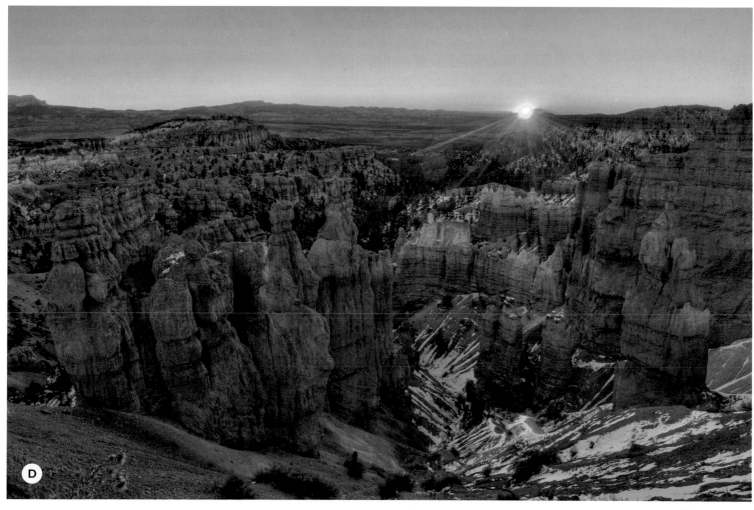

D

# Shooting Handheld Images for HDR Sets

Shooting handheld is convenient and allows for spontaneity and a carefree shooting style that the tripod doesn't. It is possible to get good results, especially with the latest improvements in image alignment in the HDR software on the market today. Remember though, alignment won't correct for softness due to camera movement during the exposure. If shooting handheld is your preferred style, get the odds on your side. Here are a few tips:

- Use Auto Exposure Bracketing in continuous shooting mode

- Get a visual lock on viewfinder markings within the scene

- Concentrate on being steady

- Use a fixed surface to steady the camera when possible

- Use your camera or lens image stabilization feature, if available

## The EV Indicator

An important part of HDR photography is the EV indicator that usually appears in the top LCD panel and the viewfinder display if your camera has this feature. The indicator has a series of tick marks and/or dots highlighting the camera's exposure metering. It's a handy visual that helps you to stay aware of your exposure compensation. The indicators often have limitations, however, so if you want an exposure outside the range of the EV indicator you'll need to mentally count the tick marks for each additional stop.

+2  +1  0  -1  -2

*A typical 2-stop EV indicator shows tick marks for full stop increments and small dots for fractional increments, in this case 1/3 stop.*

## Using a Tripod

If you're willing to go the extra distance for sharper images, I strongly recommend a good, stiff tripod and a cable release. It's best to create HDR images without touching the camera, but if you must dial exposure levels, do so as lightly as possible. If you don't own a cable release, use the camera's self-timer function. If your camera has mirror lock-up, use that as well. Any movement, even on a micro-pixel level, is enough to diminish the sharpness of the best lenses.

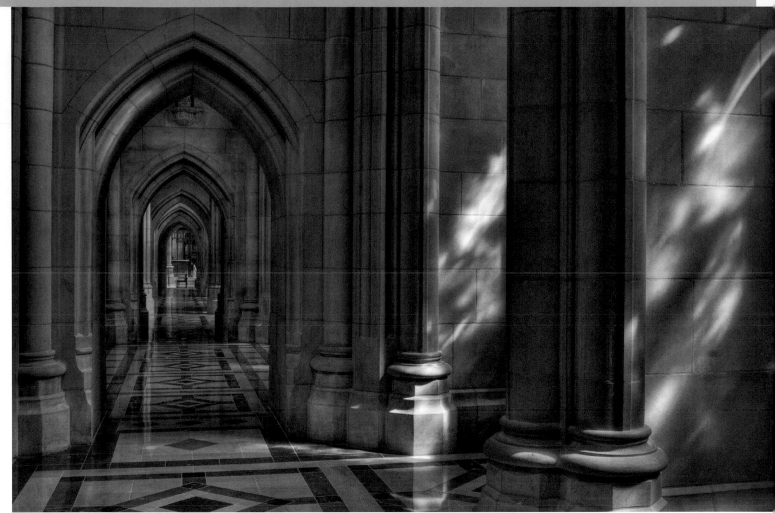

*If your tripod is placed on a hard-polished surface, using AEB and a cable release is good idea. Many buildings have polished marble floors and the tripod can easily slide around if you dial in the exposure settings manually.*

**Note:** The mirror lock-up feature is best used at shutter speeds of around 1/15 second or faster. Long shutter speeds don't really require mirror lock up, as the mirror vibrations are long gone before pixels begin to saturate.

Be aware that a rigid tripod on soft ground is not a rigid tripod. If you are outdoors, make sure to mount the tripod on firm, solid ground. Wiggle the tripod through the spongy grass or press the legs into the soft sand or mud. Put in the effort while shooting in the field, as you may not have the chance to reshoot later.

| Ideal Camera Setup | Optional Set up |
|---|---|
| Tripod and cable release | Handheld in AEB w/continuous shooting |
| Aperture-Priority mode | Manual exposure mode |
| Automatic Exposure Bracketing | Manually dial in +/- EV amounts |
| Continuous shooting mode | Single Frame shooting |
| Manual Focus | Manual Focus |
| Flash Off | Flash off |
| Multi-segment metering | Spot or center weighted metering |
| RAW 12-bit files | RAW 12-bit files |
| Low ISO to control noise | Low ISO to control noise |

# John Adams

**Artist Statement:** Although this adventure has just begun for me, my photography has been taken to levels I would have never dreamed. Not only does the HDR process overcome many of the current limits of technology and equipment, it has opened up a new plateau of discovery where vision and persona can magically transform into a new dimension of time, light, and color.

We are on the edge of a new imaging standard, and I believe these processes will eventually be integrated into digital cameras. Rather than having to download and manually combine multiple exposures on a computer, digital cameras will have built in HDR functions just as they have other scene-specific settings like Nighttime, Portrait, and Sports.

Visit http://www.flickr.com/photos/thepres/ for more innovative HDR images from John Adams.

flickr.com/photos/thepres/

© John Adams

© John Adams

© John Adams

© John Adams

© John Adams

© John Adams

© John Adams

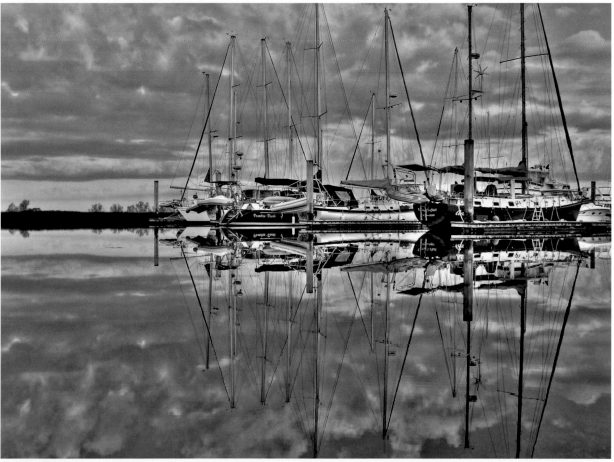

© John Adams

3

MERGING AND TONE MAPPING

**B**efore you jump right into merging to HDR and creating tone mapped images, there are a few options to consider. One option is the conversion of your RAW files to TIFF files prior to merging. If you decide to incorporate this into your workflow, there are some specific dos and don'ts to be aware of.

**Note:** Once you have downloaded your files to a folder on your computer, take the time to make a backup of the images on a CD/DVD or another hard drive. When you have completed that task, you are ready to begin the HDR workflow.

## Conversion Options

If your source images are RAW files, you have two choices. First, you can load the RAW files directly into the HDR software and allow the program to convert them to 32 bit HDR files. Second, you can convert the images into 16-bit TIFF files using a high-end RAW converter (such as Adobe Camera RAW, Adobe Lightroom, Apple Aperture, Capture One, or DXO Optics). One of the benefits of using a high-end RAW converter is that some editing and adjustments are possible before the image is merged to HDR. For example, if you find excessive noise or chromatic aberration in your source images, then it is best to correct these problems in a RAW converter prior to merging to HDR. If left uncorrected, the merging and tone mapping process will enhance the problems.

"Hey wait a minute," you might be thinking, "I thought HDR merging got rid of noise!" The HDR merging process does reduce or eliminate noise, but the degree to which it does this depends on the quality of the original images. The differently exposed images should capture the full dynamic range. That is, make sure the most underexposed image correctly exposes the highlights and the most overexposed image correctly exposes the shadows.

Noise is created at the time of capture and is an electronic issue. Image details cannot be restored or discerned due to noise. Grain is another issue that is caused by excessive local compression in the tone mapping process. Grain can obliterate details, just like noise, but it's recoverable by lowering compression.

If you have a single image that you would like to tone map, it is better to make the conversion using one of the RAW converters with noise reduction. The tone mapping process will enhance any noise in the image, so it's better to reduce the noise first. See pages 142—157 for more about single image tone mapping.

*I merged three 16-bit TIFF images (-2EV, 0EV, and +2EV) to HDR using the FDRTools software after completing RAW conversion using Adobe ACR (a Photoshop plugin).*

*I created this image using three RAW files converted in FDRTools using the dcraw conversion tool within the program.*

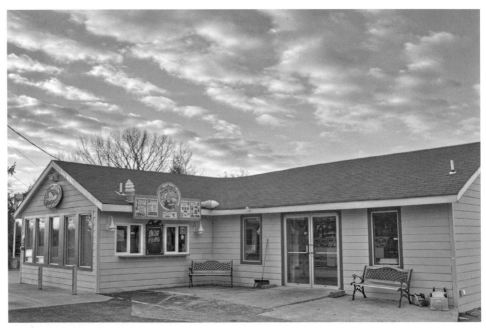

# Converting to TIFF Using Adobe Camera RAW

In Adobe Camera RAW (ACR), you can carry out noise reduction, chromatic aberration, cropping, resizing and white balance prior to merging to HDR. When a RAW file is opened in ACR, by default, the program tries to "correct" the image by applying tonal adjustments. ACR calls this "Auto" mode, and for most imaging purposes it's acceptable, but not for HDR. So, when converting your RAW images to 16-bit TIFFs using this program, make sure to set all tonal adjustments to zero.

If tonal adjustments are made, the image will no longer match the EXIF data that the HDR program uses for the merging process, and the result will be incorrect HDR values. However, if your source images have an overall exposure problem, you may elect to change all the exposure values by the same increment. If the change isn't the same (for example, if one RAW file is left unchanged and the other is +1), then the EXIF data stored in the image file will not match the tonal spacing of your images.

**"Can I create an HDR image from a single RAW file by changing the exposure values?"**

This is a common question, and it seems logically possible, but the answer is no. Many people think they can open a single RAW file in a RAW conversion program, adjust the exposure, and save each variation to create a complete exposure set ready for merging. The problem is, the single exposure has a fixed dynamic range, and changing the exposure value in post-processing doesn't create noise-free shadows or recover lost highlights. The image is bound by the limited dynamic range of the sensor, and the only way to extend the range is through multiple images at different shutter speeds.

| Adjustments to Avoid | Allowable Adjustments |
|---|---|
| The following is a list of image adjustment tools that you should avoid before merging to HDR: | The adjustments on this list can be made to images prior to merging to HDR without negatively effecting the final result: |
| Tone (be sure these sliders are set to zero or changed by exactly the same increment) | White balance |
| Brightness | Chromatic Aberration** |
| Exposure | Color noise reduction |
| Saturation | Lens distortion |
| Contrast | B/W conversion |
| Shadows | Crop |
| Curves | Resize |
| Sharpening | |

**Chromatic aberration (CA) is a phenomena where dispersion in the glass causes a variation in the bending of light with different wavelengths. When making CA corrections, be sure to apply the same corrections to all images in the HDR image set.

# Photomatix Pro Tutorial

Photomatix Pro is able to merge your source images to 32-bit RGBE or OpenEXR files and then tone map them using Details Enhancer or Tone Compressor. Another method of processing called Exposure Blending does not create a 32-bit file, but it is the primary tool used for flash merging (covered on pages 123–129).

*To load source images for a single scene, go HDR>Generate.*

**Note:** If your source images are 8-bit, they can be merged to HDR with no problems. However, tone mapping a single image is a different story. The 8-bit file must be converted to 16-bit before tone mapping is allowed.

*A box opens that allows you to browse the folders for the images you want to load.*

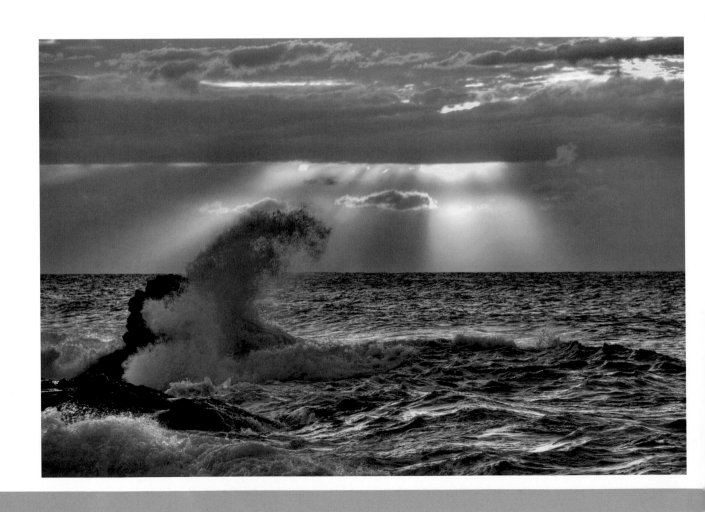

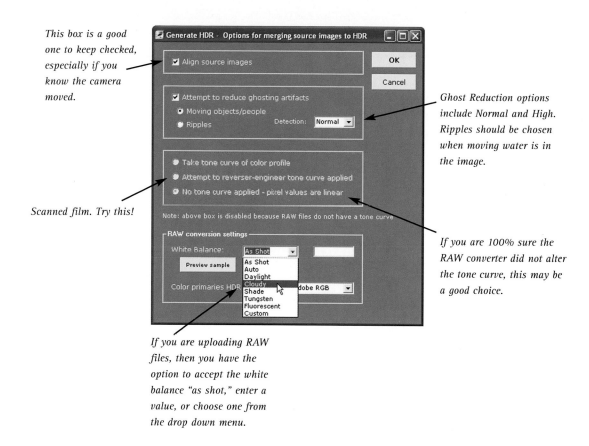

*This box is a good one to keep checked, especially if you know the camera moved.*

*Ghost Reduction options include Normal and High. Ripples should be chosen when moving water is in the image.*

*Scanned film. Try this!*

*If you are 100% sure the RAW converter did not alter the tone curve, this may be a good choice.*

*If you are uploading RAW files, then you have the option to accept the white balance "as shot," enter a value, or choose one from the drop down menu.*

## Loading Source Images for a Single Scene

There are two methods you can use to bring images into Photomatix Pro for HDR creation. The first is direct loading of the individual source images for a single scene, and the second is batch processing images from several scenes.

## Batch Processing for Multiple Scenes

After a full day of shooting, you will likely have many images to merge to HDR. If you maintained the same number of exposures (such as three exposures per image set, for example) create a folder called Source Images RAW-3. If some image sets were more than three exposures, create another folder and label it appropriately so that the batch processor doesn't mix image sets.

**Note:** Batch processing will first work on the lowest numbered files, then move to the next batch of lowest numbered files without regard to the content of the files.

Start batch processing by going to Automate > Batch Processing. This opens the batch processing dialog box, which consists of Process, Source, and Destination options. This is a convenient way to process your image sets into their respective 32-bit HDR files. I don't recommend tone mapping the images as a batch, however, as you will lose the ability to fine tune the settings for each image.

Once you have generated the 32-bit HDR file using batch processing, you will have to go to the folder and open the file using File > Open. The image that opens will look horrible, with blown out highlights and dark shadows everywhere. That's because it's the 32-bit HDR file and your monitor is unable to display the full dynamic range of the image. In order for your monitor to display the image, or if you want to print it, you'll have to tone map it.

### Exposure Blending and Flash Merging

Exposure Blending is another tool in Photomatix Pro. It blends the midtones of each of the source images into a final image. However, it does not operate in 32-bit technology. Although the tool has limited popularity when compared to Details Enhancer and Tone Compressor, it is the ideal tool for flash merging. Flash merging is a new technique I pioneered for combining several flash images into a single image, covered in detail on pages 123—129.

*Click "Run" once you've made your choices.*

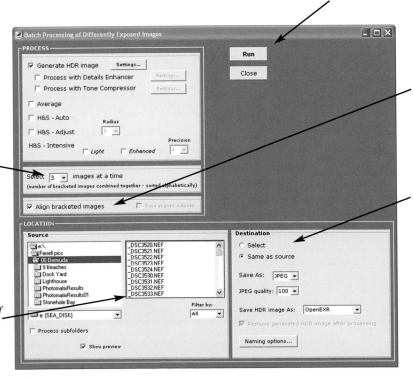

*You can process images to HDR format, tone map, and blend exposures by checking the various related boxes.*

*This window tells Photomatix Pro how many images are to be merged per image set. The number 3 is shown here because three source images make up the set.*

*If you highlight a set of files in the files box, the batch process will only work on that set of files.*

*This box is always good to keep checked, especially if you know the camera moved.*

*This is where you decide where your generated files will go and what format they will have. Individual images are saved as JPEG or TIFF, and the final merged HDR files can be saved as OpenEXR or RGBE.*

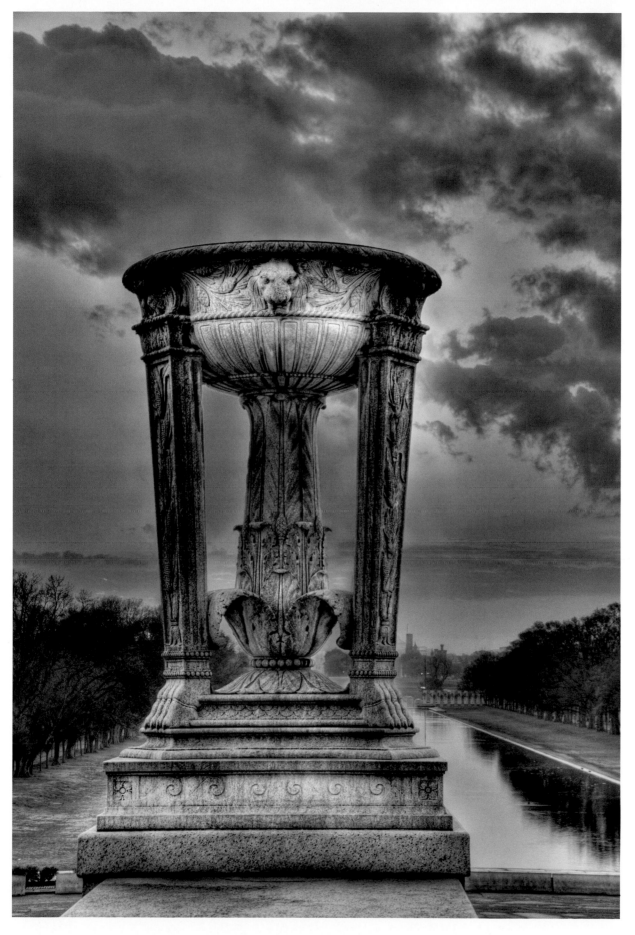

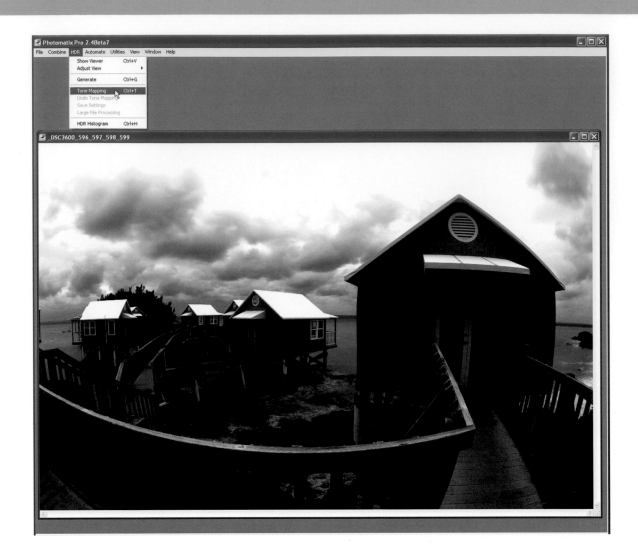

## Tone Mapping Workflow

Photomatix Pro's 32-bit merging tool, HDR Tone Mapping, can be considered the goose that laid the golden egg. It has two tone mapping operators: Details Enhancer and Tone Compressor. Images that are tone mapped using Details Enhancer can be surreal and painterly or realistic and natural. The nice thing about Photomatix Pro tone mapping is the wide variety of looks that can be achieved to suit your desired artistic expression. If Details Enhancer is too much for your taste, then Tone Compressor is an excellent choice for maintaining a natural look. If shadows are your preference, Tone Compressor can generate foreboding shadows with subtle, noise-free details.

To begin the tone mapping process go to HDR > Tone Mapping. Once the tone mapping window opens, the fun begins. The default Photomatix Pro tone mapping operator is Details Enhancer. Start by clicking the Default button to place all the sliders in their original starting positions. (If you have already done some tone mapping with this program, the settings from your previous session will still be in place.) I prefer to use the 1024 pixel preview. More pixels in the preview mean that you can work with an image that is closer to the way the full resolution image will look.

# Details Enhancer Techniques

So, we have all these sliders with many combinations; where do we begin? Are there "best" workflow techniques for achieving a realistic versus a surreal HDR look? Yes, there are, but watch out for the pitfalls that can make your image look like it was processed by an HDR amateur. One lesson you will quickly learn is that some settings will work well for one image but not another. That's why tone mapping using batch processing should be avoided.

**Step 1:** Set Gamma – Begin your work by setting the Gamma slider so midtones fall close to the middle of the histogram. Photomatix Pro is very good at determining brightness, so it usually won't be more than a slight move to the left or right.

**Step 2:** Set Strength and Light Smoothing – These two sliders should be used together and are the essential tools for controlling local tonal variations. For your image to look like a traditional photograph, move the Strength slider to the left in the range of 25 – 50 and Light Smoothing to High or Very High. For a surreal HDR look, try Strength levels from 50 – 100 and move Light Smoothing to Medium.

Most of my images are tone mapped with Strength levels in the 50 – 100 range and Light Smoothing at Medium or High. I rarely use Light Smoothing at Low, and never at Very Low. For the Beach Huts scene (on page 55), I wanted a surreal look for the clouds so I used a higher Strength setting of 92. I kept the Light Smoothing set to Very High to maintain traditional tonal relationships.

**Step 3:** Set White Point and Black Point – White Point and Black Point on the Tone tab are used to add global contrast to the image by clipping pixels to pure white or pure black. Keep in mind that these sliders also change the midtone brightness. I always try several positions for each slider, and have found that White Point and Black Point set full right at 5.00% each will create a surreal HDR effect. Most of my images end up with the two points set about half way in the range. You may elect to preserve all pixels by keeping both set to zero and apply clipping later using a general image-processing program. In the Beach Huts image (on page 55), the White and Black Points are set low to limit the contrast in the sky and keep the scene looking believable.

**Step 4:** Set Microcontrast and Micro-Smoothing – Use Microcontrast and Micro-smoothing on the Micro tab to impact the local contrast enhancements. To create an image that has maximum small-scale contrast, raise the Microcontrast to 10 (right) and lower the Micro-smoothing (left). For an image with softer transitions in local contrast, lower Microcontrast to –10 and raise Micro-smoothing to 30. Avoid moving both sliders full right or full left, as they tend to cancel each other out.

Let's say that you want the pine needles on a tree or the intricate details of fine artwork to stand out and be sharp; in such cases, raise the Microcontrast to be somewhere in the range of 0 – 10 and lower the Micro-smoothing to 0. On the other hand, if you feel that the fine details in the scene detract from the look you're trying to achieve, such as in a city scene at night or a beach scene at sunset, then lower the Microcontrast and raise the Micro-smoothing.

Most of time, I keep Microcontrast in the range of 0 – 7 and Micro-smoothing between 0 – 10. This produces images that are not over-the-top in local contrast, graininess is controlled, and the overall look is pleasing. Images that include sky are prone to grain, so consider setting Micro-smoothing between 2 – 10 and Microcontrast anywhere from 0 to –5. The Beach Huts scene (right) has Micro-smoothing set at 2, but if a print of the image showed grain, I would increase Mico-smoothing to between 3 – 5 and try again.

### Grain vs. Noise in HDR Tone Mapping

Grain is caused by excessive local compression in the tone mapping process. It can obliterate details, just like noise, but details are recoverable by lowering compression. On the other hand, details lost due to noise cannot be recovered.

*Note:* During Microcontrast and Micro-smoothing adjustments, take advantage of the 100% preview crop by clicking on the image. Simply make your adjustments in full view then click on an area in the image and a 100% preview crop of the area will be displayed. It is best to choose an object that extends into the blue sky rather than just the blue sky.

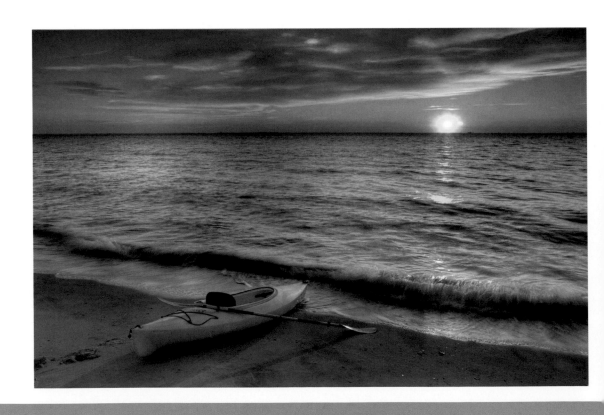

**Photomatix Pro – Details Enhancer**

Strength: 92

Color Saturation: 91

Light Smoothing: Very High

Luminosity: 5

Microcontrast: 0

Micro-smoothing: 2

White Point: 0.020%

Black Point: 0.363%

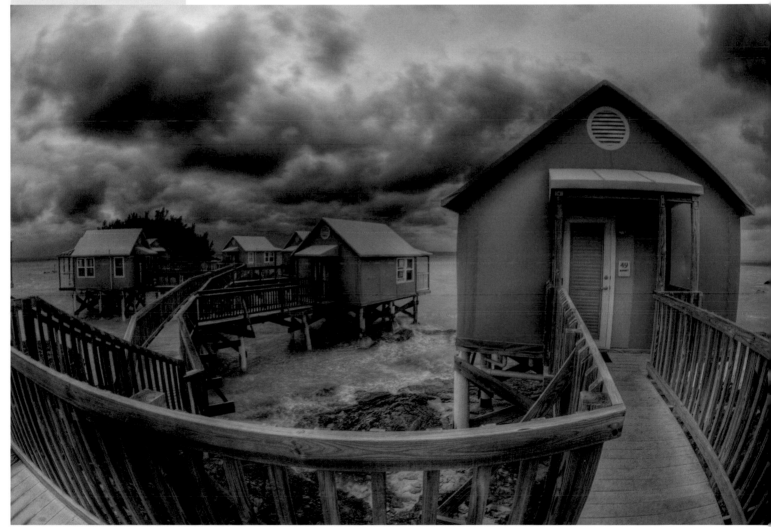

*Beach Huts: This scene was taken with a Nikon D2X, a 10.5mm fisheye lens, and a tripod. I merged five images taken at 1EV spacing to create the HDR photo.*

**Photomatix Pro – Details Enhancer**

**Strength:** 55

**Light Smoothing:** High

**Highlights Smoothing:** 60

*Castle: To create this HDR image, I used five source images taken at 1EV from each other.*

the building. The Highlights Smoothing slider on the Shadows and Highlights tab is very useful for controlling the halos created around objects surrounded by blue sky. The use of this slider will allow you to raise Strength and lower Light Smoothing for a more surreal HDR image without the halos.

If you are dealing with halos in cloudy skies rather than blue ones, however, the Highlights Smoothing slider will not work very well. The clouds don't always fall into the highlights tonal range, so smoothing is inconsistent. Unlike blue skies, images that have cloudy skies are much more tolerant of higher Strength and lower Light Smoothing values. In the image of the Portland Head Light in Maine (top right), you can see that the blue sky with clouds disrupts the creation of strong halos even though I have the Strength set at 100 and the Light Smoothing at 0.

**Tone Reversals:** Tone reversals are the result of taking regions of an image that we normally perceive as brighter than other areas and making them darker. When an image includes the sky, it becomes easy to identify a tone reversal because our visual perception that the sky is the brightest part of the scene is a strong one. The Strength and Light Smoothing settings strongly control tone reversals. Raise the Strength and lower the Light Smoothing to create tone reversal; lower the Strength and raise the Light Smoothing, and the tone reversal is corrected.

Tone reversals are more forgiving when the scene does not include sky; it is possible to push the envelope much further before problems appear. When we don't have a familiar visual reference like the sky, we are more accepting of the visual effects of higher Strength and lower Light Smoothing. Compare the settings of the Porch image (bottom right) with those of the Castle image (left).

**Minimizing Halos:** A halo is fringe of brightness around an object that extends into a region of uniform tonality. A building that extends into a blue sky is a good example of where halos often develop. The blue sky in the Castle scene (above) was particularly problematic where the sky meets a dark roofline of

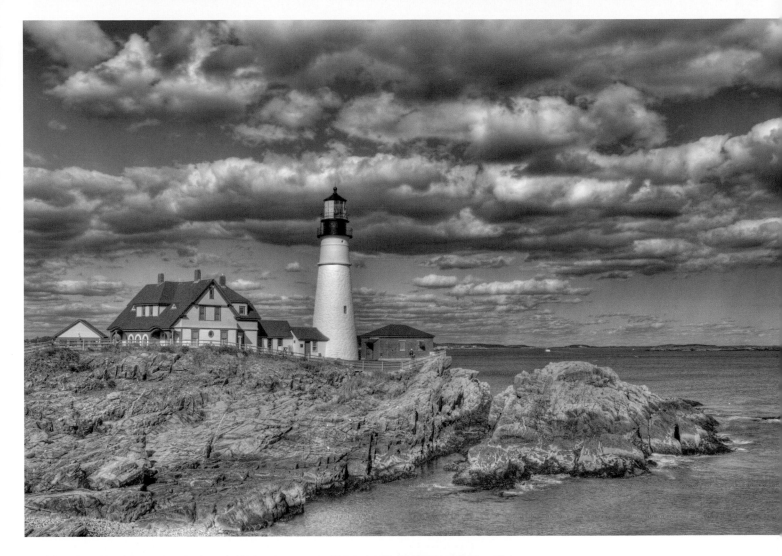

Photomatix Pro – Details Enhancer

Strength: 80

Light Smoothing: Medium

Highlights Smoothing: 0

*Porch: To create this HDR image, I merged five images at 1EV step from each other.*

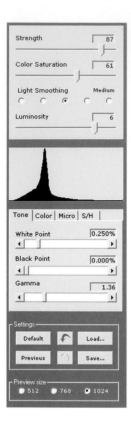

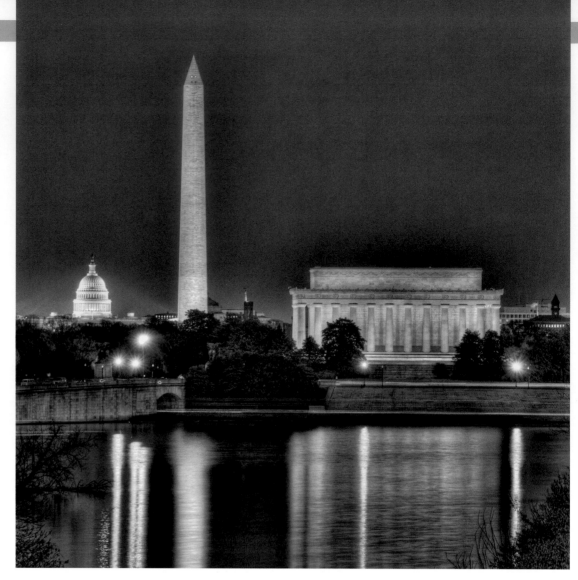

**White Surfaces:** When HDR images are tone mapped, it is common for white areas to be rendered gray. The Highlights Smoothing slider on the Shadows and Highlights tab is the tool for turning the gray areas back to white. I typically set the white color to a very high-key gray and then apply a Levels adjustment later in an all-purpose image-processing program.

**Noise in the Shadows:** To correct camera noise in the shadows, try to desaturate the shadow area by using the Saturation Shadows slider on the Color tab. This will help with color noise. You can also raise the Black Point and follow with Shadows Clipping on the Shadows and Highlights tab to create black areas in the shadow regions and, in effect, lower the visibility of the noise.

**Controlling Grain Enhancements:** Grain commonly appears in skies and is most evident when you zoom in closer than 100%. If your image has high grain due to image compression, you can try these slider adjustments to mitigate the problem. Remember to adjust the slider when viewing the full image then zoom in to 100% to see the results:

• Lower the Strength values
• Raise Light Smoothing to High or Very High
• Lower Luminosity
• Raise Highlights Smoothing
• Raise Micro-smoothing

Here is a strongly tone mapped image of the Lincoln Memorial, the Monument and the Capitol Building (above). The buildings look nice, but the sky is full of grain. The easy

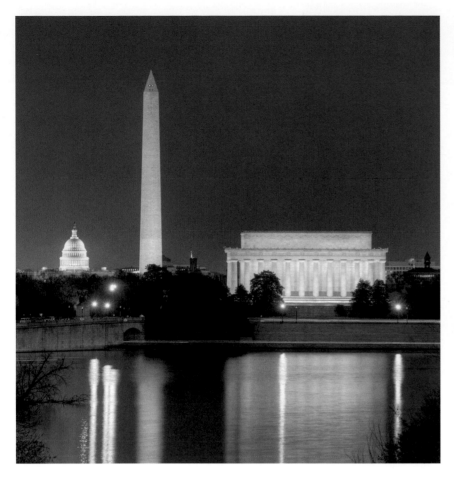

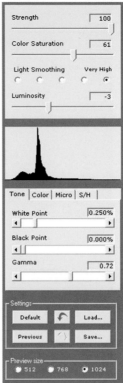

solution would be to lower the Strength, but if we look at the other settings, it becomes apparent that there are a few other adjustments that can be made to help the situation. Notice the positions of the Luminosity and Gamma sliders. As the Luminosity slider moves to the right, it increases brightness and micro-compression. The Gamma slider also increases brightness as it moves to the right. In this case, if we want to reduce compression, the sliders positions need to be reversed.

When I move the Luminosity slider to the left, it lowers the micro-compression but also darkens the image, so I counter the darkness by moving the Gamma slider to the right. Notice the position of both sliders in the second image (above), where grain is substantially reduced. The Micro-smoothing slider (not shown—located on the program's Micro tab) was moved from 0 to 4 to further reduce grain. The image now shows an overall improvement in grain reduction, but will still need some Levels and Curves adjustments later in post-processing.

The important point here is to know that the Luminosity, Microcontrast, Micro-smoothing, and Gamma sliders can all be used to fine-tune the brightness and smoothing of the image. They are interrelated and when one is moved, another can be adjusted to maintain harmony in the image.

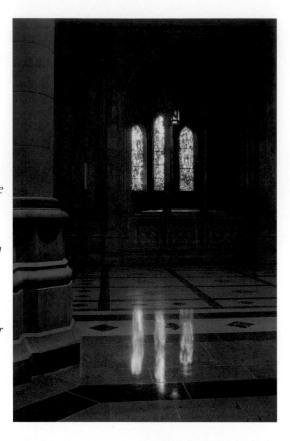

*Taking pictures at The National Cathedral in Washington D.C. should be done during the winter months when the sun is low in the sky. HDR photography is perfect for this location. The top image was processed using the Tone Compressor operator, which preserved the shadow areas, while the image below was processed using the Details Enhancer operator, which opened up the shadow areas.*

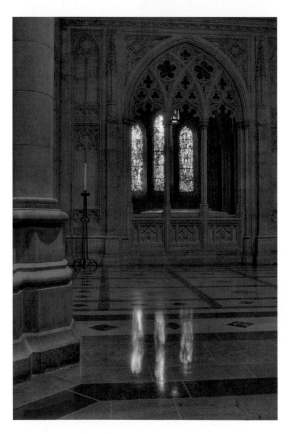

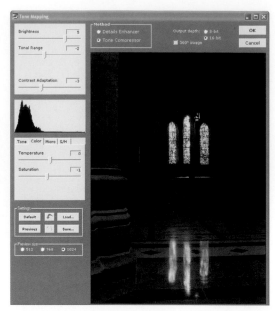

*The Tone Compressor dialog box has three tonal adjusters, a White and Black point adjuster, and active controls under the Color tab. The other tabs (Micro and Shadows and Highlights) are inactive in Tone Compressor.*

## Tone Compressor

Tone Compressor is Photomatix Pro's second tone mapping operator, and it can be easily activated by clicking on the radio button in the Method box. If you desire a more traditional looking image, then this global operator is the perfect tool. One advantage of using Tone Compressor is the preservation of shadows with good control of the tonal range. In some images, dark shadows play an integral role in creating a mood. The Details Enhancer tone mapping operator would open up the shadow areas rather than preserve them; Tone Compressor is the perfect operator for controlling the shadow areas. It is very easy to use, and has a histogram for viewing the changes as you make them.

**Tone Compressor Controls:** The following is a list of the controls available in the Tone Compressor global tone mapping operator. You will notice that there are not nearly as many as in Details Enhancer, but the goal here is to create a more traditional looking image, so a wide variety of controls is not needed.

**Brightness:** This slider globally changes all the pixels in the tonal range and, if increased enough, can create blown or overly bright pixels.

**Tonal Range:** The Tonal Range slider is similar to the Brightness slider except that the compression factor simply shifts the highlights and shadows toward the center of the histogram. A good method is to begin with the image darker than you prefer (i.e., Brightness and Tonal Range around –3). Then start to increase each slider by one increment. If the highlights begin to look too bright, drop the Brightness back one and compensate for the drop in brightness with a Tonal Range increase by one. Remember Tonal Range clamps down on the brighter pixels better than Brightness. Continue this give and take experiment between the Brightness and Tonal range sliders until the image tones appeal to you.

**Contrast Adaptation:** This slider substantially changes the contrast of the image. Lower values create high contrast images while high values create low contrast images.

**Tone Compressor vs. Details Enhancer:** The following image examples illustrate some of the differences between the Details Enhancer and Tone Compressor tone mapping operators. As mentioned previously, the Tone Compressor operator renders much more realistic and natural looking images, while the Details Enhancer operator is great for pushing the boundaries of visual possibility.

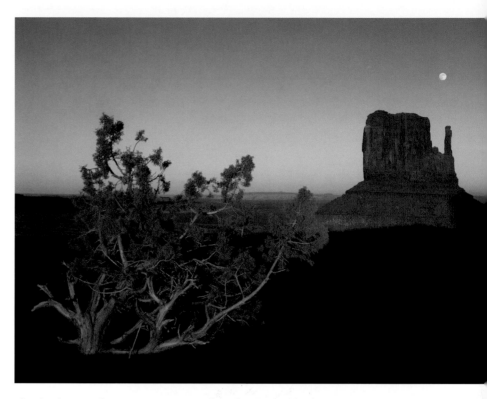

*In the image above, you can see that the Tone Compressor operator rendition maintains the shadow as a prominent subject in this scene as compared to Details Enhancer rendition, below. Don't forget that shadows can add mood to the overall image, so you may want to preserve them.*

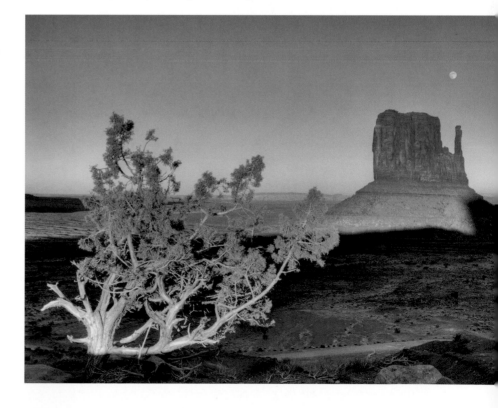

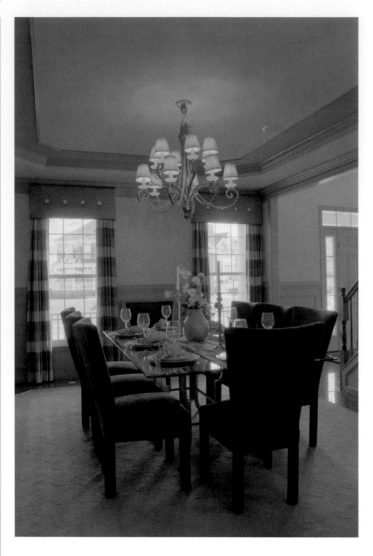

For this scene, the Tone Compressor operator rendered a more natural looking image (top), as expected, while the Details Enhancer operator's local contrast enhancements have made the walls look dirty (right).

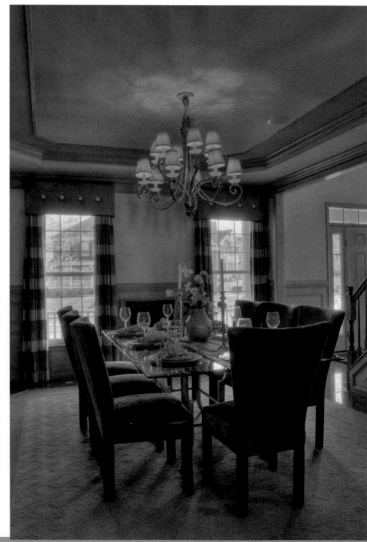

There are times when shadow details—as opposed to merely the shadows themselves—are an essential part of the image. In these cases, Tone Compressor is not a good choice. Here, the words above Lincoln are lost in the shadows when Tone Compressor is used (above). Details Enhancer, on the other hand, makes it possible to see the shadow details (below).

# Domingo Leiva

**Artist Statement:** For the last few years, I have been using HDR techniques as a base for my digital photographic work. I usually take three images at 2EV spacing for scenes where all the image elements are static. For scenes with movement, I shoot a single RAW file and tone map it to create an HDR photo.

I do additional post-processing on my HDR images to restore image contrast and texture, including meticulous Levels adjustments. My ultimate goal is to achieve a hyper-realistic, painterly representation of the scene with high regard for deeply dramatic subjects.

Visit http://www.flickr.com/photos/dleiva/ for more amazing HDR work by Domingo Leiva.

flickr.com/photos/dleiva/

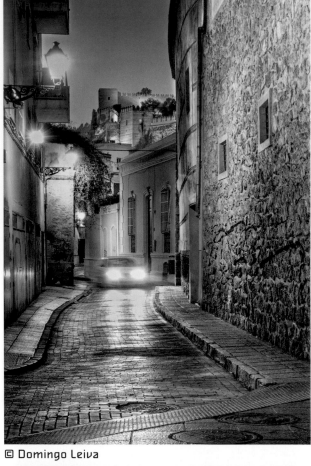

© Domingo Leiva

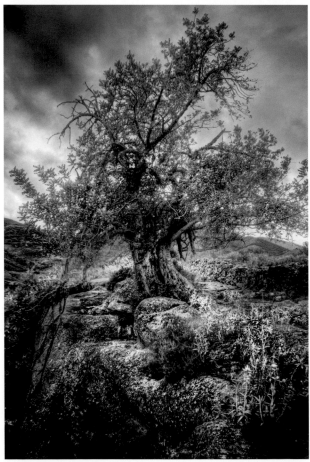

© Domingo Leiva

© Domingo Leiva

© Domingo Leiva

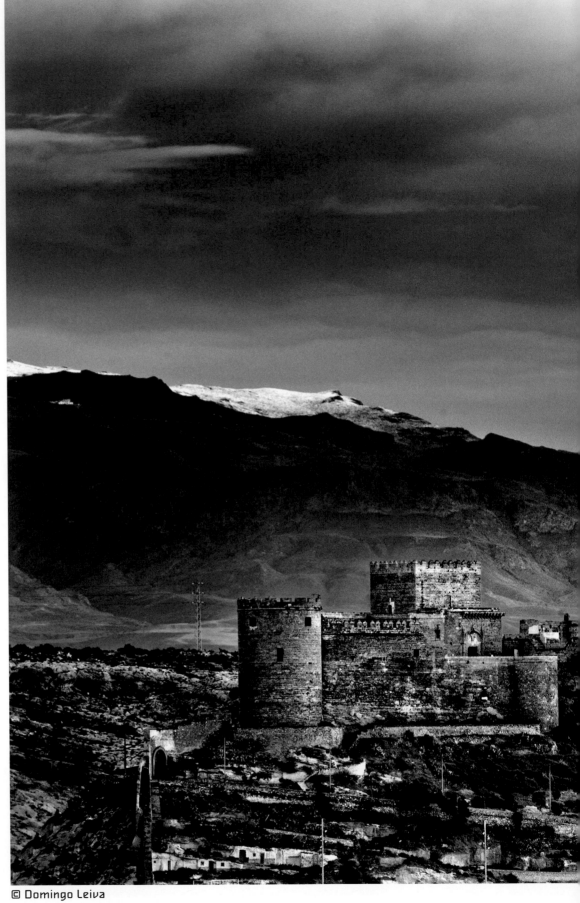

© Domingo Leiva

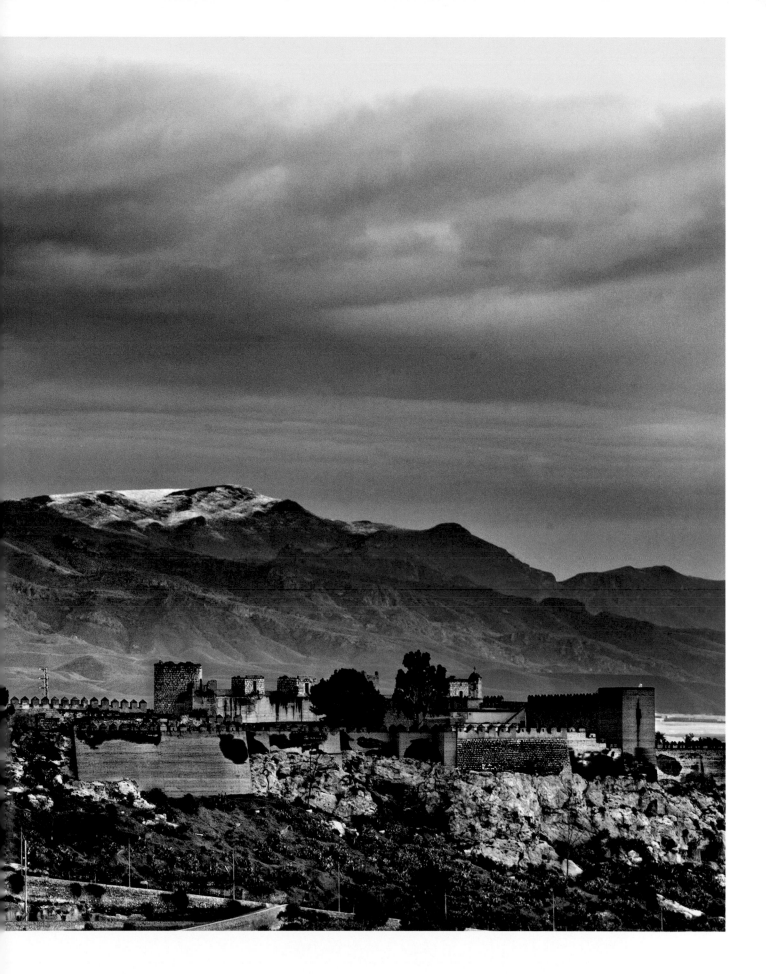

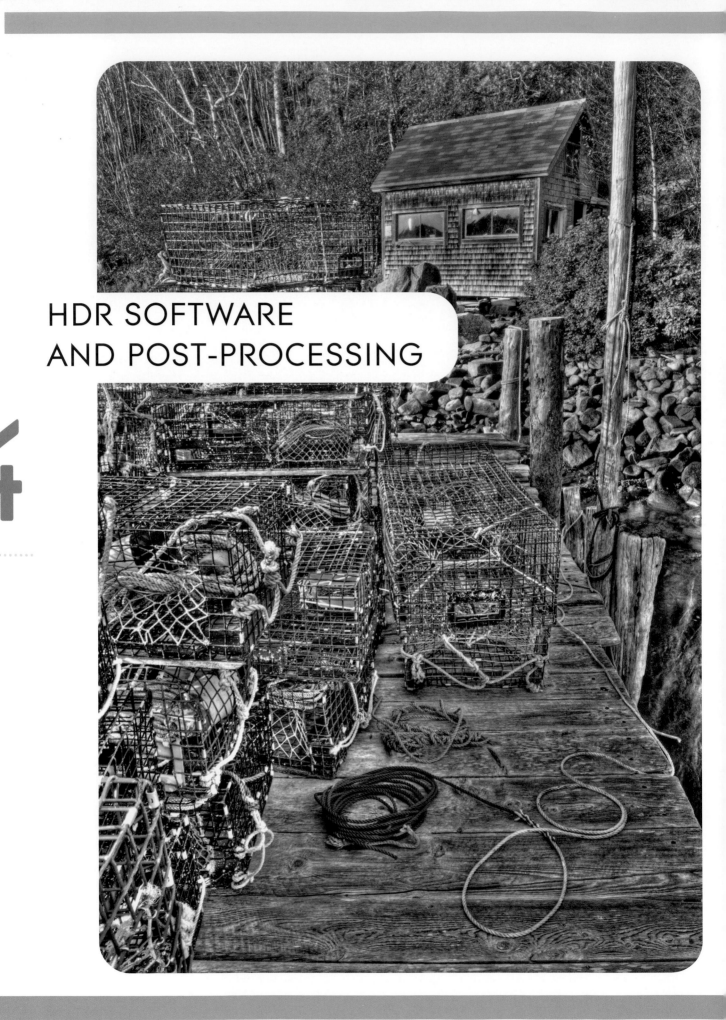

# HDR SOFTWARE
# AND POST-PROCESSING

4

There are two basic types of HDR software programs: Those that are exclusively for HDR creation, and those that include HDR creation as part of a full image-editing package. If you choose to get software that is dedicated to HDR creation, I would also advise you to get a full image-editing software package to put the final touches on your HDR image.

**Dedicated HDR Software**
Photomatix
FDRTools
Dynamic Photo HDR

**Software with HDR Processing Options**
Adobe Photoshop (version CS2 and later)
Artizen

## Software Overview

| Program | Platforms | Photoshop Plugin | Image Editor |
| --- | --- | --- | --- |
| Photomatix Pro | Windows, Apple | Yes | No |
| FDRTools Advanced | Windows, Apple | Yes | No |
| Dynamic Photo HDR | Windows, Apple (via Boot Camp Assistant software) | No | Limited |
| Artizen HDR | Windows | Yes | Yes |
| Adobe Photoshop CS3 | Windows, Apple | N/A | Yes |

**HDR Software and RAW Conversion**

All of the software programs in this chapter are capable of converting RAW files to HDR images, and each of them use a converter based in whole or in part on a program called dcraw. The dcraw converter is an ANSI C program (the standard published by the American National Standards Institute—ANSI—for the C programming language) written by Dave Coffin that decodes RAW images from any digital camera using any operating system. It's a widely used, highly successful open source decoder.

## HDR Creation and Tone Mapping

| Program | Batch Processing | Read/Write HDR Files | Image Align Tool | Ghost Removal Tool | Tone Mapping Operators | Ability to Save Tone Mapping Parameters | Crop Image | Rotate Image | Modify White Balance | Processing Speed |
|---|---|---|---|---|---|---|---|---|---|---|
| Photomatix Pro | Yes | Yes, .hdr and .exr | Automatic, Manual | Normal, High | 2 | Yes | Yes | Yes | Yes | Fast |
| FDRTools Advanced | Yes | Yes, .hdr and .exr | Automatic only | Yes, using Separation tool | 3 | No | No | No | Yes | Very slow |
| Dynamic Photo HDR | No | Only .hdr | Automatic, Manual | Yes | 6 | Yes | No | No | No | Fast |
| Artizen HDR | Yes | Yes, .exr, .hdr, and artizen formats | Automatic, Manual | Coming soon | 11 | Yes | Yes | Yes | Yes | Very Fast |
| Adobe Photoshop CS3 | Only via Extended Script** | Yes, .hdr and .exr | Automatic only | No | 4 | Yes | Yes | Yes | Yes | Medium |

**ExtendedScript is Adobe Photoshop CS3's JavaScript-based scripting language. The program does not have a separate batch processing application, though it is capable of accepting one via third party software.

# Photomatix Pro

Photomatix Pro, made by a company called HDRSoft, is an all around excellent program for getting consistent results with little effort. It is quickly becoming a mature, well-established program for HDR merging and tone mapping. The workflow is easy, and the program has all the necessary features to create HDR images using batch processing or single HDR generation. Generally, images are bright, airy, and full of life with well-developed midtones.

Details Enhancer and Tone Compressor are the program's tone mapping operators. They allow for either detail enhancement or a more realistic look, and it's easy to jump from one operator to another. The program is easy to use; it processes quickly and allows for a wide variety of surreal images. An automatic ghost removal tool is also available and does very well in most cases. Image alignment can be automatic or manual and is a necessary feature when images are taken handheld.

# FDRTools

The FDRTools program, created by Andreas Schömann, has good control of the entire 32-bit dynamic range and is able to consistently obtain excellent results, even with the default settings. Its local contrast enhancements are better than any other program on the market, and the software's masterful ability to render fine details makes it an excellent program for producing large prints.

FDRTools is the only program that allows for the control of pixels during the HDR merging process. It offers three merging methods: Average, Separation, and Creative. Average is the standard method used most of the time; merging and tone mapping are interactive, allowing the user to omit a source image and immediately see the tone mapping results. The Separation method allows for manual control of ghost removal, and the Creative method is good to use when light is changing in the scene, as well as being ideally suited for flash merging (see pages 123–129).

Images created using FDRTools tend to have a darker mood, skies are deeper blue particularly when compared to an HDR image created with Photomatix Pro. However, the images can be "mood-adjusted" using the Curves and Levels tools in post-processing.

FDRTools runs slowly when saving images but, during processing, if the viewing window is made small, the processing speed is comfortable. The program interface is very basic, but the upside is that it is very easy to go from merging to quality output. The Separation and Creative merging techniques take some getting used to; fortunately, they are not needed often. When it comes to surreal renderings or going wild with tone mapping, don't look to FDRTools for the solution. It sticks close to the philosophy of strong, detail-oriented images that are realistic when viewed. The sliders don't have the range for extreme work.

# Dynamic Photo HDR

Dynamic Photo HDR, by MediaChance, is a Windows only program, but it's the kind of program that will have Intel-Mac owners hurrying to install Boot Camp (a program that allows you to install and run Windows on a Mac). The Dynamic Photo HDR interface is easy to understand, allowing you to get to the nitty gritty of tone mapping in no time. There are six tone mapping operators, allowing for a wide variety of image renderings.

These tone mapping operators—with names like Eye Catching, Photographic, and Human Eye, to name a few—allow for a variety of effects from a single exposure look (minus the noise) to a surreal look. During the tone mapping process, you can adjust curves and color or convert to black and white with Heavy Sky and Hard Light filters. If you shoot handheld, you will find that the program has both automatic and manual image alignment options. However, manual alignment can be tedious and sometimes unsuccessful. Also, be aware that, with some images, the program's HDR merging algorithm creates artifacts and exaggerated chromatic aberration, so have a close look at your final image.

# Adobe Photoshop

Adobe Photoshop (versions CS2 and later) works fine with low to middle contrast scenes, but high contrast scenes will require skillful adjustments with the Curves tool. At times, you will find it impossible to get good results in CS2; CS3, on the other hand, shows some improvement in highlight control. When the contrast of an image is within the working limits of Photoshop, you can expect excellent detail and good color accuracy, though the HDR merging algorithm can create color artifacts when too few images are merged or ghosting is present. (See pages 115-117 for more about ghosting.)

Local Adaptation is the most useful of the four Photoshop tone mapping operators; it has Radius and Threshold sliders and a Curves dialog box. Local Adaptation is easy to understand, though good results can be hampered by the tedious adjustments needed with the Curves tool. Photoshop offers many alternatives to rendering images and can create some amazing special effects. However, you should note that the program's HDR tone mapping operator is not the ideal tool for creating special effects.

# Artizen HDR

Artizen HDR, by Supporting Computers Inc., is a full image-processing program, but in keeping with the scope of this book we will only review the quality and functionality of the HDR merging and tone mapping tools. Merging to HDR is easily accomplished and the program runs very fast. Image alignment is good and workflow is easy. When you begin tone mapping however, it's an entirely different story. There are many tone mapping operators and many sliders to work with and no one operator is the single answer. Tone mapping images in Artizen HDR can be time consuming; default settings are rarely ideal, so each image requires tweaking. Out of all the program's operators, Lock06 usually gives the best results.

In general, Artizen HDR does well with contrast and color and it opens the shadow areas nicely, but it has difficulty with the bright parts of the scene, particularly skies. Skies are usually flat and have a dull gray color that becomes worse with a higher contrast scene. Artizen HDR images also show a loss of detail due to noise, which is fine for small prints but for large prints, the quality is lacking.

# Overview

All of the software programs included here offer a free trial so you can explore for yourself and make an informed decision as to what works best for you. Photomatix Pro and FDRTools are quite different in their approaches to HDR, and both programs are worth having in your HDR toolbox. The images they produce are excellent but they have significantly different tones, colors, and contrast. I prefer to process an image with both programs and then decide which I like better. Dynamic Photo HDR is shaping up to

being a leader in HDR imaging, and most images are well rendered. In some situations, however, the merging algorithm produces artifacts.

If you need a software program that can do basic image-processing as well as HDR creation, Photoshop and Artizen HDR are worth looking into. Their pricing is quite different, and that may be a deciding factor. When it comes to HDR photography, Photoshop and Artizen HDR do fine with low and middle contrast scenes, but each have areas where they struggle with quality when dealing with high contrast. One of the disadvantages of these two programs is the amount of tweaking needed to get a good-looking image every time.

# Software Comparison

Princeton University Episcopal Church
The beautiful Episcopal Church (built in 1867) on the campus at Princeton University in New Jersey is the location for the source images in this comparison of HDR software capabilities. The objective is to compare the rendering of details in the scene for each program and with the single 0EV original exposure. The interior of the church is dimly lit and, ignoring the small light sources, it qualifies as a middle contrast scene. The stained glass is mostly filtered light except for small regions of lightly tinted glass, which allows for higher levels of daylight to enter.

## To create the following examples:

- Three source images were taken, one each at +2EV, 0EV, and -2EV

- The camera was mounted on a carbon fiber tripod

- I used a cable release and the mirror lock-up feature to minimize camera shake

- Images were shot in RAW format: 2848 x 4288 pixels using a 10.5mm fish eye lens

- RAW files were entirely processed within the illustrated software programs; no outside RAW converters were used

- Each image was tone mapped using selected tone mapping operators within each program

- The working color space was AdobeRGB (1998)

- Each tone-mapped image was saved at full resolution as a 16-bit TIFF file

- Each image received a black-and-white point adjustment in the tone mapping dialog box if it was not preset; all other settings were left at their defaults

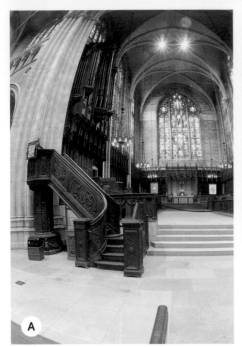

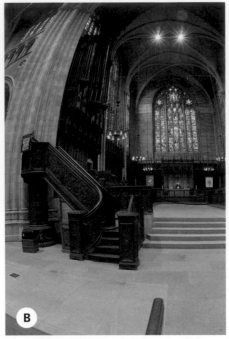

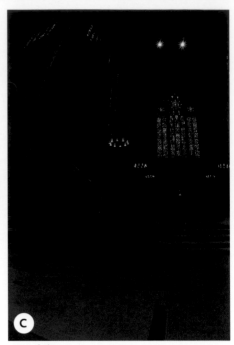

*Here are the three source images of the church, taken at +2EV (A), 0EV (B), and –2EV (C).*

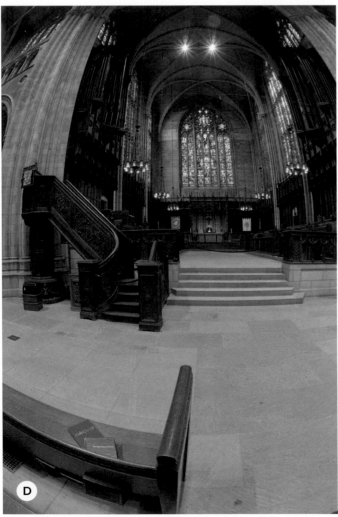

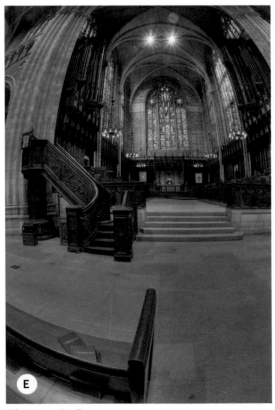

*Photomatix Pro*

*The single 0EV exposure was processed in Adobe Camera RAW, and I then made white point and black point adjustments using Levels. This will serve as the base 0EV processed image for comparison with the HDR images in this section.*

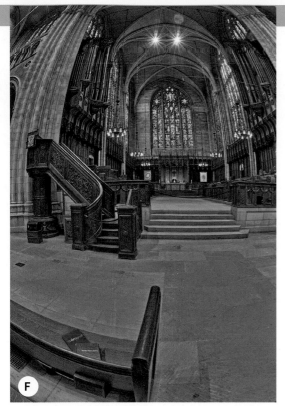

*FDRTools*

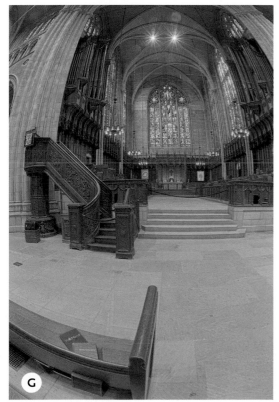

*Dynamic Photo HDR*

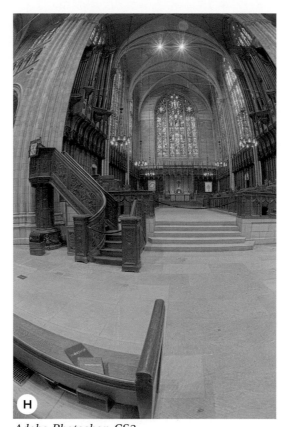

*Adobe Photoshop CS3*

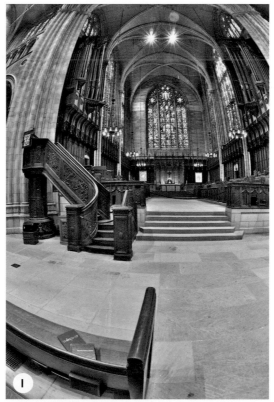

*Artizen HDR*

The original 0EV exposure (D) captured a middle contrast scene and is near the upper limit of the dynamic range that a D-SLR can capture. It has some blown pixels and some dark shadows, but they are relatively insignificant and don't detract from the overall image. When comparing the single 0EV image with HDR images as a whole, there are two salient points. First, the single 0EV image has greater global contrast. Second, the single 0EV image has greater noise. Having greater global contrast is not a bad feature, it's actually the look we are all accustomed to; however, the noise is bad and it destroys the finer details of the image.

In Photomatix Pro, Details Enhancer is a local operator that consistently yields good results with little effort. It provides good contrast, but the color has a slight magenta/red cast (E). The Photomatix Pro image is slightly softer than the single 0EV image (D), but it has noise-free detail and displays a higher dynamic range.

The FDRTools software program has a local tone mapping operator called Compressor that does an exceptional job rendering the details of the scene. The image (F) has low noise with excellent local detail enhancements and is arguably the best of all the software programs I tested when it comes to detail enhancement. The overall color is fairly accurate, but leans toward saturated reds. In comparison to the original 0EV image, the FDRTools image has better color, noise-free detail, and dynamic range.

In the Dynamic Photo HDR image (G), I used the Eye-Catching tone mapping operator. The image has a warmer tone than the single 0EV exposure and very little noise. Overall, details are well defined, though the stained glass colors are brighter, but show signs of clipping (i.e., the pixels are approaching white and no longer have color value). However, the clip-

ping is correctable during tone mapping. The image also displays good contrast, which eliminates the need for subsequent Levels and Curves adjustments.

For the Photoshop CS3 HDR image (H), the only editing done was setting the black and white points in the Local Adaptation tone mapping operator dialog box; Radius and Threshold values were left on default. Local Adaptation does an excellent job with shadow details, but insufficient small-scale contrast enhancements leave the image looking flat. The overall color is accurately captured, giving the image a realistic look. The flag with the white dove shows nice detail and saturation. When compared to the original 0EV image, the Photoshop CS3 HDR image has better color, noise-free detail, and dynamic range.

The Artizen HDR software image (I), created using the local tone mapping operator Lock06, suffers from a loss of detail due to noise, most likely retained from the –2EV exposure. Overall, though, the image has good impact, color saturation, and local contrast. When comparing the Artizen HDR image to the original 0EV image, however, there is a loss of detail due to noise in the Artizen HDR image. Additionally, the 0EV image has more details in the highlights.

## Bass Harbor Head Light

The cliff side Bass Harbor Head Light is located on the southwestern side of Acadia National Park and marks the entrance to Bass Harbor. Day after day, photographers make their way down the cliff to find a prime spot to photograph the lighthouse. The setting sun in the background and dark jagged rocks with strong shadows create a high contrast scene.

Moving water also adds an HDR merging challenge, increasing the risk of artifacts, blending errors, and ghosting. I only merged two images for this HDR photo (+1EV and –2EV) to minimize ghosting along the surf.

Once again, FDRTools shows excellent detail enhancements throughout the image (J). A close inspection shows limited artifacts confined to the moving water. Photomatix Pro (K), Photoshop CS3 (L), Dynamic Photo HDR (M), and Artizen HDR (N) have artifacts in the trees, water and sky in varying amounts, and the CS3 image is lacking small-scale contrast enhancements. Part of the success of Photomatix Pro is its ability to render a beautiful blue sky and, as shown here (K), it renders the blue color better than the other programs.

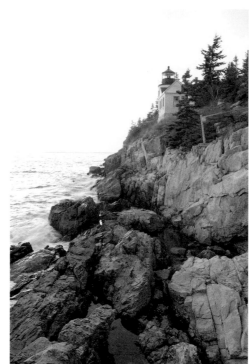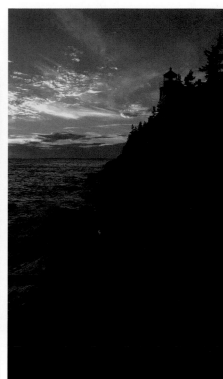

*Here are the two source images: +1EV (left) and –2EV (right).*

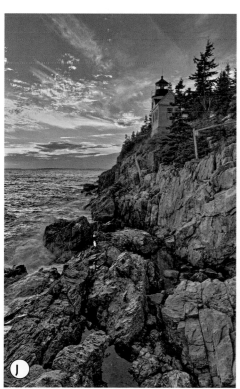

*FDRTools*

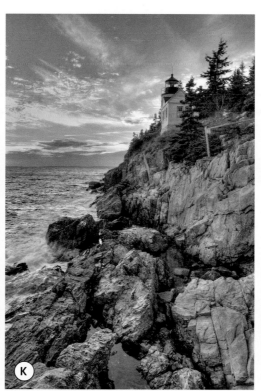

*Photomatix Pro*

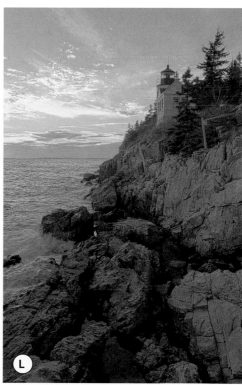

*Adobe Photoshop CS3*

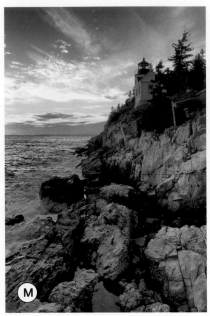

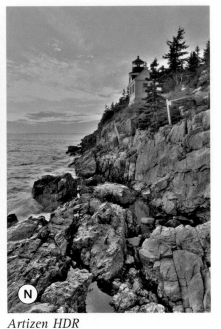

Here is a crop of the sky from each software program's rendition of the Bass Harbor Head Light HDR image and I've included the single –2EV source image (O) for comparison. Ideally, we would like to see the sky of the tone mapped image closely resemble the –2EV image, as that is the proper exposure for the sky. As you can see, FDRTools has done an excellent job (P), as it has avoided clipping, similar to the –2EV image. Photomatix Pro (Q) and Dynamic Photo HDR (R) show some clipping of the brightest areas, though it is fairly minor. Photoshop CS3 (S) does an okay job with clipping, but Artizen HDR (T) lacks good control of highlights and sky color.

*Dynamic Photo HDR*

*Artizen HDR*

*Single –2EV source image*

*FDRTools*

*Photomatix Pro*

*Dynamic Photo HDR*

*Adobe Photoshop CS3*

*Artizen HDR*

## Dealing with Moving Water

Moving water is always a potential problem, as surface reflections can result in the merging of a region that is dark in one image and bright (even blown) in the next. The problem is further complicated when the underexposed image has the bright reflection. Let's take a look at how the various software programs deal with this problem.

FDRTools has an area of black at the base of the splash (U) but is the best overall image with the fewest artifacts in the water. Photomatix Pro (V) and Dynamic Photo HDR (W) have done well with the splash but show minor artifacts throughout the water region Artizen HDR did a fairly good job (X); it has no ghosting artifacts, though it does lack sharpness. Photoshop CS3 (Y) has many blue artifacts. These artifacts most often occur in Photoshop when there are moving subjects in the scene or when there are not enough images used for merging.

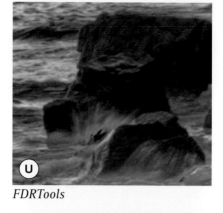
*FDRTools*

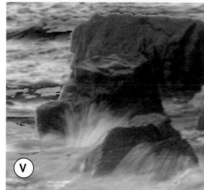
*Photomatix Pro*

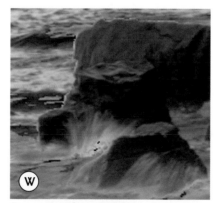
*Dynamic Photo HDR*

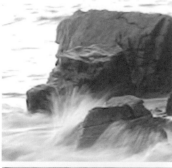

*The splash in the +1EV source image top is absent in the –2EV image bottom setting up the potential for merging problems in the surf.*

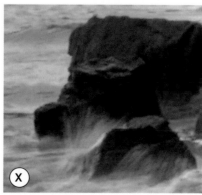
*Artizen HDR*

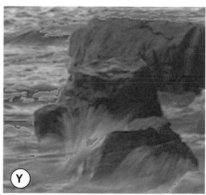
*Adobe Photoshop CS3*

# The Creative HDR Look

One of the criteria for comparing HDR programs should be how well they create "the HDR look." So, what is the HDR look? Technically, the HDR look is actually a "tone mapping look" because it is a product of tone mapping and not HDR merging. Whichever phrasing you prefer, this specialized "look" is one of extreme tone mapping to the point that the image no longer looks like a traditional photograph (see pages 170–174 for more about extreme tone mapping). It can vary widely, but generally involves strong color saturation, high levels of local contrast, and remarkable shadow luminosity to the point that tonal boundaries are crossed. The look has been referred to as painterly, surreal, and even cartoonish when tone mapping is really pushed to the limit.

Photomatix Pro, in particular, offers a wide range of creative control. If you want to achieve a realistic HDR image similar to what your camera takes as a single 0EV image, use the program's Tone Compressor global operator or lightly apply strength (20 or below) in Details Enhancer operator. On the other hand, creating more painterly images is as easy as a few slider moves in Details Enhancer operator. Photomatix Pro can easily span the entire spectrum from real to surreal, and of all the HDR software programs, it allows the most creative control.

Photomatix Pro – Tone Compressor

Brightness: 4

Tonal Range Compressor: –2

Contrast Adaptation: 2

White Clipping: 0.35%

Black Clipping: 0.20%

**Photomatix Pro – Details Enhancer**

Strength: 90

Color Saturation: 70

Light Smoothing: –1

Luminosity: 10

Micro-contrast: 2

White Clipping: 0.153%

Black Clipping: 0.200%

Artizen HDR is also able to create images that are both realistic and surreal with many different looks. The realistic image illustrated on page 83 (top) was tone mapped using the Lock05 operator and the surrealistic image (page 83 bottom) was tone mapped using the Fattal operator.

FDRTools is limited in its creative control of an image. It's hard to get that "gone-too-far" feeling in FDRTools. Each slider in the Compressor operator has limited impact on the image, even when brought to maximum levels. The program lacks a Light Smoothing tool (available in Photomatix Pro) to give the image that extra surreal look.

Artizen HDR – Lock05

Luminosity: −1.57

Saturation: 0.22

Strength: 0.32

Radius: 0

Adaptation: 1

Contrast: 0

Highlights: 0

Shadows: 0

Midtones: 0

Artizen HDR – Fattal

Luminosity: 0

Saturation: 0.5

Strength: 0.75

Micro:     0.71

Soft Light: 0.76

Contrast: 0

Highlights: 0

Shadows: 0

Midtones: 0

FDRTools – Receptor

Compression: 5

Brightness: 5

Saturation: 1.20

FDRTools – Compression

Compression: 10

Contrast: 10

Smoothing: 5

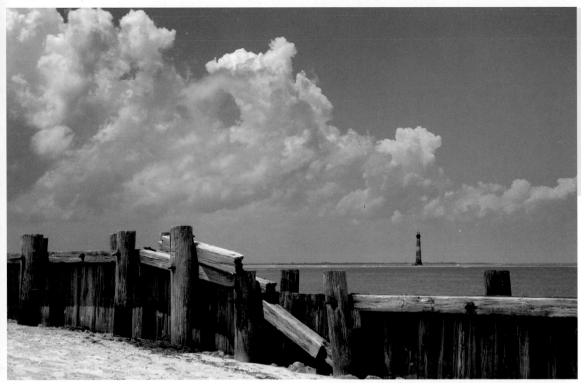

**Dynamic Photo HDR – Eye Catching**

Brightness: 13.4

Color Saturation: 0.24

Vivid Colors: 0.1

Dramatic Light Radius: 3.2

Dramatic Light Strength: 0.27

Surface Smoothness: 0.74

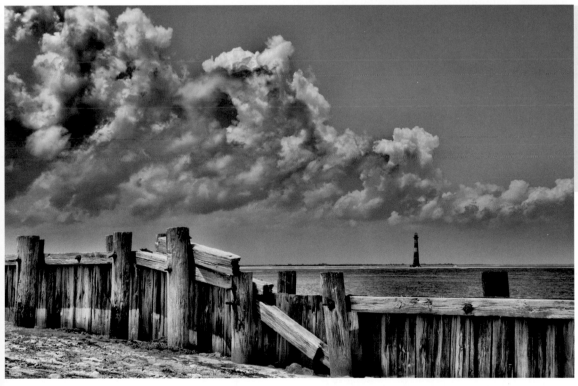

**Dynamic Photo HDR – Eye Catching**

Brightness: 13.4

Color Saturation: 0.20

Vivid Colors: 0.1

Dramatic Light Radius: 14.4

Dramatic Light Strength: 0.87

Surface Smoothness: 0.41

Dynamic Photo HDR is able to create surreal images by using two sliders: Dramatic Light Radius and Dramatic Light Strength. (The image effects are similar to Light Smoothing in Photomatix Pro.) Be careful though, as the program has a tendency to over saturate color as the sliders are moved to the extreme. In any program, adjusting the image to look more surreal can create unattractive halos, especially in the sky. In this particular case, the blue sky of the surreal image (bottom) was fixed by blending the sky from the −1EV exposure in post-processing.

# Post-Processing HDR Images

Tone mapped HDR images are rarely perfect when the HDR program finishes with them. They can look flat, lack overall contrast, and can suffer from artifacts, ghosting, and halos. Many problems, however, can be easily corrected in post-processing by using Levels or Curves, Layers blending modes, simple cloning, or an overall blending of the tone mapped image with another image to restore realism. You can choose to blend any combination of images, from the original RAW file, to a single tone mapped image, or even two HDR images processed with different tone map settings. Still another possibility is to blend an HDR image created with a local operator such as Details Enhancer (from Photomatix Pro) with an HDR image created with a global operator such as Tone Compressor (also from Photomatix Pro).

For the purposes of this discussion, I will be referring to post-processing with Adobe Photoshop CS3. Don't worry if you don't have this particular program, though, as most general purpose image-processing programs have similar tools and commands. The techniques outlined here can easily be applied to the software you have on hand, and don't hesitate to contact your software's manufacturer if you have any questions.

## Restoring Image Contrast

HDR images have compressed tonal ranges, making this post-processing step essential for all HDR images. The Lincoln Memorial (left) has been tone mapped conservatively to avoid halos and noise, but in spite of light tone mapping, the image is flat and hazy. To raise the contrast (using Adobe Photoshop CS3), go to Image > Adjustments > Levels, or try placing the Levels adjustment on a layer of its own. This will allow masking, blending, opacity changes and later editing of the Levels adjustment. Simply click on the black/white circle at the bottom of the Layers palette and choose Levels.

The outer two sliders of the histogram map the black point and white point, and by default are set to 0 for black and 255 for pure white. Drag the black and white sliders inward until they just begin to touch the main group of pixels, then click OK.

The next step is to use the Curves tool; go to Image > Adjustments > Curves, or enjoy additional Curves control by clicking on the black/white circle at the bottom of the Layers palette and choose Curves. This will place the

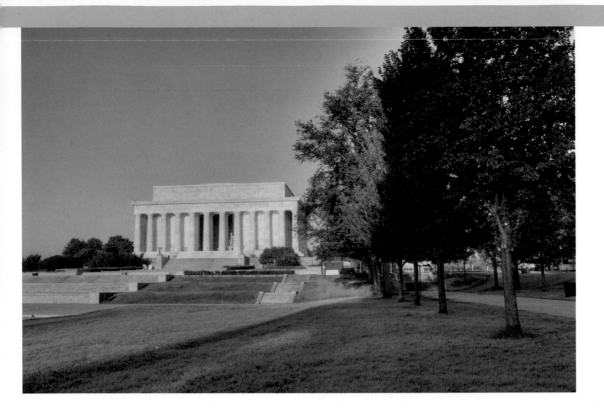

If you want to see the actual pixels that are being clipped, press the Apple key (or the Alt key if you use a PC) while moving either outside slider. The image turns black when you drag the white point slider and white as you drag the black point slider. As the slider is moved inward, colors will begin to replace the solid black or white regions as clipping is introduced. How far past initial clipping you move the slider is a matter of taste, but it is good practice to move the sliders to at least the beginning of clipping.

Curves adjustment on its own layer and allow masking, blending, opacity changes and later editing of the Curves adjustment. To add a point along the curve, click directly on the curve and drag it. Move the point on the Curves line (and/or create multiple points) to adjust the tones in the image. The object is to

preserve highlights and shadows and add contrast to the midtones by creating a slight "S" shape to the Curves line. After Levels and Curves, there is a noticeable improvement in global contrast, as seen in the image above.

## Blending with Layers and Masks

Layers and Masks are particularly valuable (perhaps even essential) tools for the digital photographer. They allow us to realize our artistic expression by giving us manual control over how the features of various images come together. But why bother with blending? Blending allows you to correct problems in an HDR image, like ghosting and artifacts, or blend features of one image into another for optimal effect. Here are a few ideas of what to blend:

• 1. Blend the HDR image with a single RAW source image. This can restore realism to the final HDR image and resolves problems that may have occurred during HDR creation or tone mapping (noise, halos, etc.).

• 2. Blend the HDR image with a single tone mapped image. This allows you to maintain the HDR look but correct problems that may have occurred during merging (such as ghosting or artifacts).

• 3. Blend two HDR images, one from a local operator and the other from a global operator. From Photomatix Pro, for example, you could blend a Details Enhancer HDR image and a Tone Compressor version of that HDR image. You could even process two HDR images with different programs and blend the results.

## HDR Image + RAW Source Image:

When a scene has buildings and trees that come in contact with the blue sky, you can count on halos. The only way to avoid the halo effect is lower compression to the point that the tone mapping effect is barely visible. If you find that high compression makes everything look great except for the halos, then it is best to correct the image in post-processing.

The Lincoln Memorial image has been dramatically compressed with a high Strength slider setting in Photomatix Pro. The result is a severe halo in the sky (A). The best way to correct the problem is to use a Layers Mask in Photoshop and blend the great-looking sky area from the –2EV source image (B) with the HDR image. Here's how to accomplish that using Adobe Photoshop:

• 1. Open both images in Photoshop.

• 2. Drag the –2EV image over the HDR image using the Move tool while holding down the Shift key to ensure exact alignment.

• 3. From the –2EV layer, select the sky area using the Magic Wand tool. Uncheck "Contiguous" and set "Tolerance" to about 20. The Shift key adds to the selection and Alt/Option key subtracts from the selection.

• 4. After you have selected the sky, then feather the selection. In Photoshop CS3, use the new Refine Edge command to feather the selection. In CS2 or earlier, feather anywhere from 1 – 10 pixels.

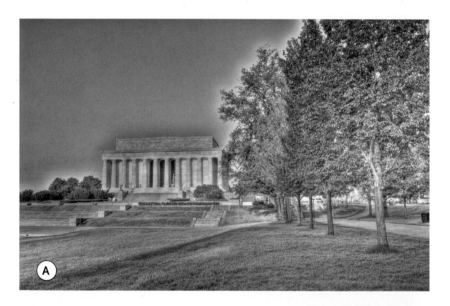

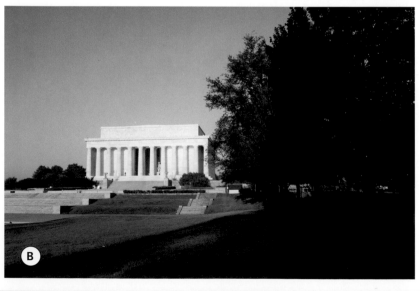

*Here is the final Lincoln Memorial image I made by merging the Photomatix Pro HDR image with the sky from the -2EV source image.*

• 5. Now click the Add Layer Mask button in the Layers palette.

• 6. Inspect the feathered area and redo it if needed with a different feather amount.

• 7. Save the final image with a new file name so you don't overwrite the old file, in case you want to refer back to it.

## HDR Image + Tone Mapped Image:

Now let's try blending with method number two, using an HDR image and a single tone mapped image. In this example, the single tone mapped image was created using the Photomatix Pro Details Enhancer tone mapping operator. The HDR image of the waterfall (right) was made by merging five images at 1EV spacing. I used shutter speeds of 1.5, 3, 6, 12, and 25 seconds with a constant aperture of f/18. The HDR image is well rendered, but the longer exposures added more blur than I wanted to the leaves spinning in the foreground. I preferred the look of the spinning leaves in the single 0EV, six-second exposure (page 90–top).

*This is the HDR image, created by merging five different exposures at 1EV spacing from each other.*

*Here is the 0EV image, the six-second exposure.*

*This is the final HDR photo, created by blending the earlier version of the HDR image with the spinning leaves of the single 0EV image.*

I had two choices; I could either go use the single 0EV shot as my final image, or blend the leaves from the single 0EV shot into the HDR image. To help me decide, I zoomed in to look at the details of both images. When the shadow areas are enlarged, it's easy to see the improved detail in the HDR image, so I knew that adding the leaves from the 0EV image into this otherwise superior rendition was the best choice, especially if I wanted to make a large print. The following steps illustrate how I created this blend.

• 1. Open both images in Adobe Photoshop.

• 2. Drag the HDR image over the single tone mapped image using the Move tool and holding down the Shift key to ensure perfect registration.

• 3. Click the Add Layer Mask button in the Layers palette.

• 4. Select the Mask of the HDR image and begin painting over the leaves area with a soft brush. Paint in black until the spinning leaves of the Single 0EV image are revealed.

• 5. Save the final image.

**HDR Image + HDR Image:** It is possible to create two different tone mapped HDR images of the same scene and then take the good parts of each image and blend them. When tone mapping an image, it's not unusual for a particular compression setting or software program to do great with one part of an image but not another. For example, FDRTools does a very good job of creating strong local contrast enhancements, and Photomatix Pro is very good with blue skies.

For this image of Horse Shoe Bend, I wanted to use the canyon from FDRTools (C) and the sky from Photomatix Pro (D). Each image underwent an entirely different compression scheme. The FDRTools canyon scene is highly compressed, which caused the sky to develop problems with vignetting, noise, and posterization. Conversely, in Photomatix Pro, the sky scene is lightly compressed with minimum contrast and maximum smoothing. This compression scheme creates a noise-free sky with smooth tonal gradations. Blending two HDR images is the same as blending any other image set, so refer back to the steps outlined in the previous two sections to bring out the parts of each image that you want to feature in your final photo. As you can see, the final blend of the two Horse Shoe Bend HDR images turned out very nicely (E).

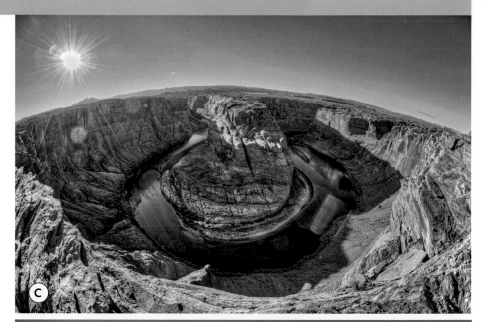

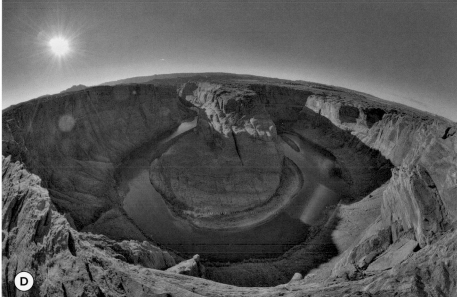

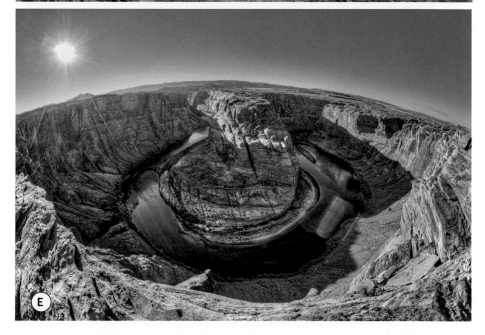

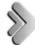

# Asmundur Thorkelsson

**Artist Statement:** I've had a fascination with visual arts ever since I can remember. When looking at paintings and photographs hanging on walls, I became immersed in them. I daydreamed about running around in the landscapes, entering the buildings, and walking the paths depicted in these images. It wasn't long before I felt the urge to create images of my own.

In 2005, I discovered www.flickr.com and saw the many wonderful things amateur photographers were doing. It was through flickr that I first became acquainted with HDR photography. I saw a sunset image along a sandy beach, by Amery Carlson, and I was mesmerized by the beautifully lit foreground with rich detail and color against a bright background. With time and practice, I have learned to use HDR techniques to dramatize my own photographic images.

Visit http://flickr.com/photos/asmundur/ for more striking HDR imagery from Ásmunder Thorkelsson.

flickr.com/photos/asmundur/

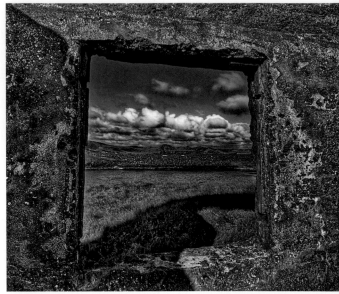

© Asmundur Thorkelsson

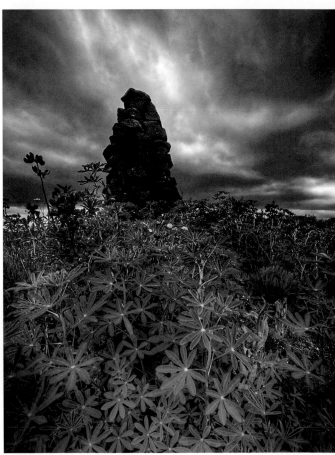

© Asmundur Thorkelsson

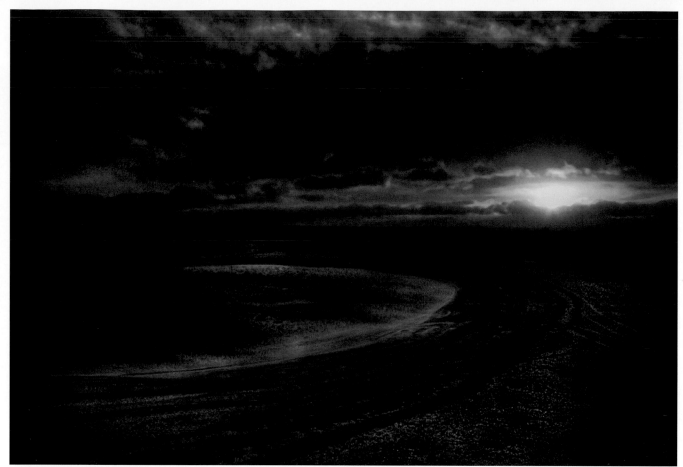

© Asmundur Thorkelsson

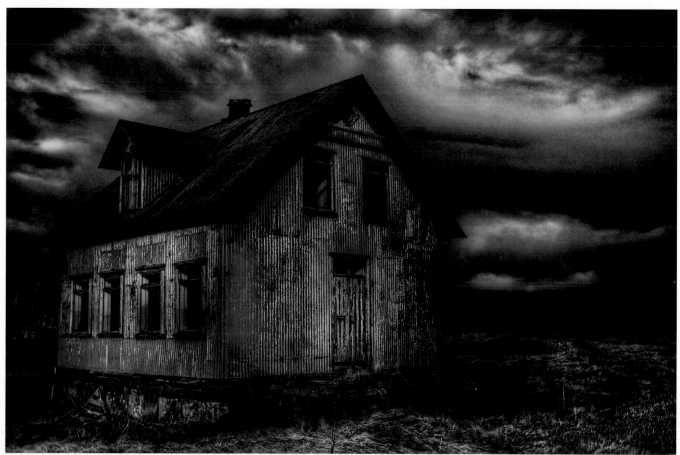

© Asmundur Thorkelsson

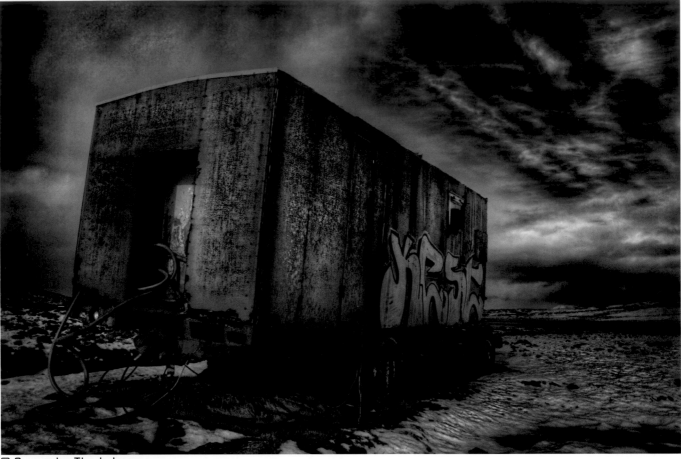

© Asmundur Thorkelsson

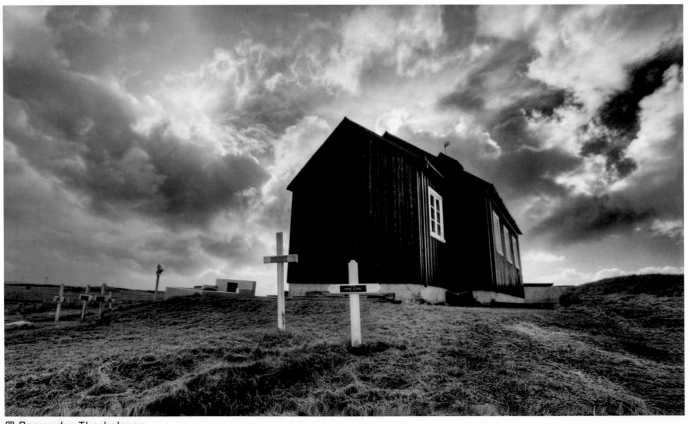

© Asmundur Thorkelsson

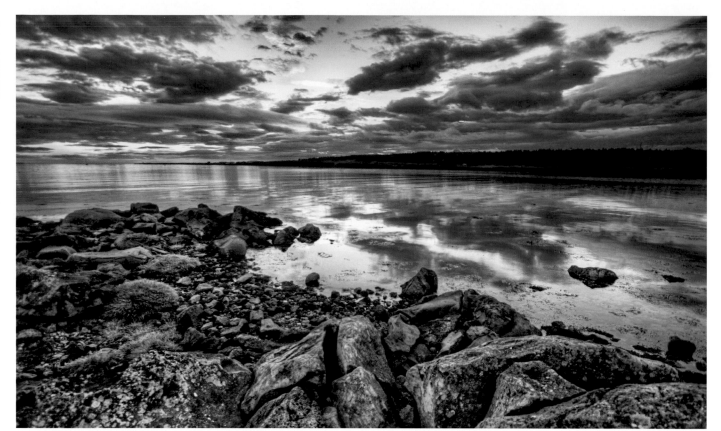

© Asmundur Thorkelsson

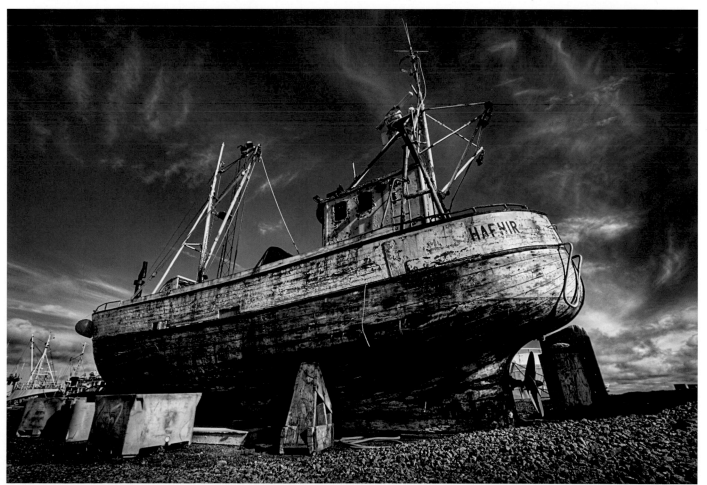

© Asmundur Thorkelsson

# 5

## CAPTURING GREAT SOURCE IMAGES

HDR photography has many different applications in the photographic world. Architectural interior photographers can solve the extreme contrast situations and simplify the complex flash arrangements customized to each location. Landscape photographers can shoot new subjects that they would normally pass by. Large panoramas capture an enormous dynamic range of light. HDR photography can expand your potential subjects in all sorts of situations. It can breathe new life into your creative side and allow you to see the world in an entirely different way.

## Judging Contrast

What are the ideal conditions for HDR shooting? Any scene with static subjects and a higher contrast range than your D-SLR can capture makes for great HDR shooting, though you don't necessarily have to limit yourself to these ideals. The first step is to visually analyze the contrast of the scene.

We perceive two kinds of contrast: color and brightness. Color contrast is not an important factor in determining dynamic range, but brightness is. Here's a quick exercise to determine the range of brightness for any scene: Switch to spot metering in your camera and take a reading of the brightest and the darkest areas of the scene. The difference in exposure stops is the EV range of your scene. Here are some common shooting situations and the EV ranges I recorded. Note whether the EV range makes the scene high dynamic range (HDR), medium dynamic range (MDR), or low dynamic range (LDR).

From this chart, we can develop a few basic concepts that apply to almost all outdoor scenes. The contrast of the scene depends on the direction that your camera is pointed. Point toward the sun and you are working with a high contrast backlit scene; point at

## Dynamic Range for Common Scenes

| Scene | EV Range | Dynamic Range |
|---|---|---|
| Interior with sunlight beaming through a window | 14EV | High contrast: HDR |
| Night scene with street lights | 12EV | High contrast: HDR |
| 100 watt bulb in a small interior room | 12EV | High contrast: HDR |
| Sun overhead with some shade areas | 8EV | Medium contrast: MDR |
| Sunny day side-lit subject that includes shade areas | 7EV | Medium contrast: MDR |
| Overcast sky with shade areas | 6EV | Low contrast: LDR |
| Sunny day front-lit scene that includes sky | 4EV | Low contrast: LDR |
| Subjects under overcast skies with sky not included | 3EV | Low contrast: LDR |

### Additional Considerations

Shooting into a building from outside can be a high contrast scene. The "cave" effect usually has dark shade regardless of the direction of light.

• Reflective surfaces have to be treated as a light source. A reflection of the sun or any other light sources will dramatically increase the contrast. Small reflections can be ignored, but large reflections need to be considered.

• A dimly lit scene can be low contrast. For example, a dimly lit room is likely low contrast if the source lights are not included in the composition.

• During twilight and dawn, the contrast is relatively low unless you point the camera at the rising or setting sun.

• A brightly lit scene can be low contrast. A picture of clouds in the sky, although very bright, is low contrast as long as the sun is not included.

• Don't try to expose for the sun's disc. Allowing the sun and a region around the sun to be blown is acceptable in photography.

90° degrees to the sun and you are in a middle contrast side-lit scene; shoot with your back to the sun and your are in a low contrast front-lit scene. Use the direction of light to help you identify the scene's contrast, then determine the number of exposures and bracketing required to capture the entire dynamic range of the scene.

# HDR for High-Contrast Scenes

If you point your camera toward the sun, any object between you and the sun will be back-lit. The camera will read the sky at its brightest and the shade at its darkest. This sets the stage for high contrast, and thus requires additional images to capture the full dynamic range of the scene. For such situations, the common exposure sequence of three images at 2EV spacing is usually not adequate (see pages 102–105 for more about number of images and bracketing amount).

You can be sure of two things when shooting into the sun: lens flare and high dynamic range. The Horse Shoe Bend image, at right, is an HDR image created by merging seven images at 1EV spacing, covering an EV range of –3 to +3, which was sufficient to capture a saturated blue sky nearly up to the disc of the sun. When the sun is close to the horizon, the lighter blue color near the horizon is a natural occurrence and should not be confused with a halo that occurs during tone mapping. For the final image, I blended the HDR image file I created in FDRTools with one I created in Photomatix Pro. (See pages 106–107 for details on how to blend two HDR images.)

**Photomatix Pro – Details Enhancer**

**Strength:** 37 (lowered to avoid blue-sky halos)

**Color Saturation:** 63

**Light Smoothing: High**

**Luminosity:** 3

**Micro-contrast:** 1

**Micro-smoothing:** 22 (set at the maximum to reduce blue-sky halos)

**Highlights Smoothing:** 80

**White Point:** 0.075%

**Black Point:** 0.059%

*Salters Depot, South Carolina: The sun is partially blocked in this high contrast scene, yet there is still strong backlighting. I shot three images at 2EV spacing and one additional +3EV image for shadow detail.*

*For this side-lit medium-contrast scene, I merged three images at 2EV spacing in FDRTools, and tone mapped using the Compressor operator.*

FDRTools – Compressor

Compression: 6.5

Contrast: 6.5

Smoothing: 1.3

## HDR for Medium-Contrast Scenes

If I point my camera at 90° degrees from the sun, the landscape will be side-lit. The direction of the light creates more diffused light in the shadows. This is a medium-contrast scene, and can be very successfully captured using three images at 2EV spacing, or five images at 1EV spacing, which equates to the same range.

## HDR for Low-Contrast Scenes

A low-contrast scene is typical when skies are overcast. The cloud cover creates a huge soft-box effect that softens shadows and diffuses light. In addition to overcast skies, a front-lit scene is low-contrast. The background sky is the darkest portion of the sky, and the landscape is at its brightest. Thus, the overall contrast is low. D-SLRs are very capable of capturing the dynamic range of these scenes in a single image. However, nothing says you can't shoot a low-contrast scene for HDR processing; I've done it many times. You can take three images at 2EV spacing, or even at 1EV spacing, and both will be successful HDR images.

Photomatix Pro – Details Enhancer

Strength: 80

Color Saturatlon: 70

Light Smoothing: High

Luminosity: 2

Micro-contrast: 0

Micro-smoothing: 2

White Point: 1.318%

Black Point: 0.87%

*Overcast skies and front lighitng created a low-contrast scene, so I was able to tone map a single OEV image and avoid ghosting of the waving flag.*

# Number of Images and Bracketing Amount

The approach to shooting HDR photography is one of capturing enough dynamic range that the HDR merging software has something valuable to work with. That means image sets with no gaps due to excessive spacing in EV, or image sets that don't capture the entire dynamic range of the scene. You don't want to make giant leaps in EV values, but you also don't want to take baby steps. The name of the game is overlap of data, but not so much overlap that it becomes redundant. As a general rule, less than 1EV spacing between images is too little, from 1EV to 2EV is ideal, and over 2EV spacing is too much. For the purposes of analyzing the number of images and bracketing amounts needed for merging, we are going to assume that the dynamic range capturing capabilities of your digital camera sensor equal 6EV. This estimate is arguably low, but I'd rather err on the side of creating higher quality images.

> *Note:* Tests performed by Imatest (www.imatest.com) show a dynamic range of 8.5EV for most digital sensors. However, quality is diminished by the presence of noise. 6EV pertains to a range that is low in noise and high in quality.

The skills in knowing how many images to take and at what EV will come with time, but for starts it is advisable to shoot at least three images at 2EV spacing. Then, if necessary, add more frames at 1EV spacing beyond the image set. Some photographers shoot very few images while others shoot a large number. Ultimately, the goal is to become proficient at reading the contrast of a scene to determine the number of frames needed and the bracketing amount.

## Three Images at 2EV Spacing: The Bracketing Workhorse

The easiest way to jump into HDR photography is to begin by setting the camera up to shoot in autoexposure bracketing (AEB) mode with either three images at 2EV spacing or five images at 1EV spacing, depending on what your camera's presets are. Both of these image sets and bracketing sequences will capture a 10EV dynamic range. If AEB mode is not available with your camera, simply dial in the exposure variations manually using Manual exposure mode or exposure compensation.

### Quick Review

The contrast of the scene depends on the direction that your camera is pointed. Point towards the sun and you are working with a high contrast back-lit scene; point at 90° degrees to the sun and you are in a middle contrast side-lit scene; shoot with your back to the sun and your are in a low contrast front-lit scene. Use the direction of light to help identify the scene's contrast, then determine the number of exposures and bracketing required to capture the entire dynamic range of the scene.

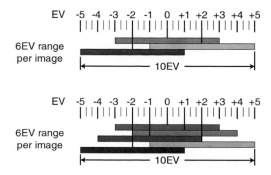

*Almost all D-SLR cameras with AEB mode can take three images at 2EV spacing or five images at 1EV spacing. The total range captured is 10EV for both presets, which covers the majority of scenes.*

## When Do You Need More Than 10EV?

The answer to this is twofold. First, make an educated guess on scene contrast. Second, if the scene is high contrast, shoot the workhorse image set (three images at 2EV spacing) and check the histogram of the most underexposed (–2EV) and most overexposed (+2EV) images. If the underexposed image has blown highlights, take another image at –3EV and recheck the highlights. Continue underexposure until you create an image where the highlights are not blown.

Next, look at the overexposed image and ask yourself if it really opens the shadow details enough. If not, take another image with added exposure value. At this point, there is no harm in taking a few more images for added comfort. I've shot the workhorse image set many times only to add two more images to insure better highlight and shadow capture. Later, as we will see in the histogram analysis (pages 112–114), you can omit images that don't add to the merging process, but it's better to start off with too many than not enough.

## Scene Awareness

There's more to photography than reading histograms. It's important to develop scene awareness that takes you beyond what the histogram can tell you. For example, if a region of brightness or darkness if fairly small in relation to the overall composition and you want that area to be properly exposed, additional bracketing will be needed to ensure good exposure of that area, and that may not be apparent if you merely judge the scene by its histogram.

Shooting three images at 2EV spacing is sufficient for most scenes, but in certain situations, a fourth or fifth image is needed to fully capture the highlight and shadow areas. Let's take a scene with the sky in the upper third of the frame. In matrix or zone metering, the camera is going to expose for the darker landscape, as it comprises the majority of the scene. The camera will bracket based on the shadow areas and place less emphasis on the narrow, bright area occupying the edge of the frame. Thus, the underexposed image (–2EV) may not be sufficiently underexposed for the bright sky. The best solution in this case would be to add one image at –3EV or –4EV to give a margin of safety for capturing the full sky color. With good scene awareness, you can avoid onsite histogram analysis if you anticipate how your camera will meter the scene.

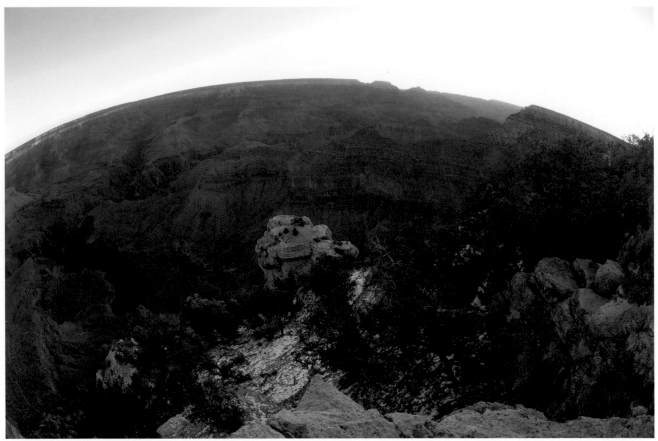

*This is the single 0EV image. Notice that the canyon is well-exposed, but the sky is blown out.*

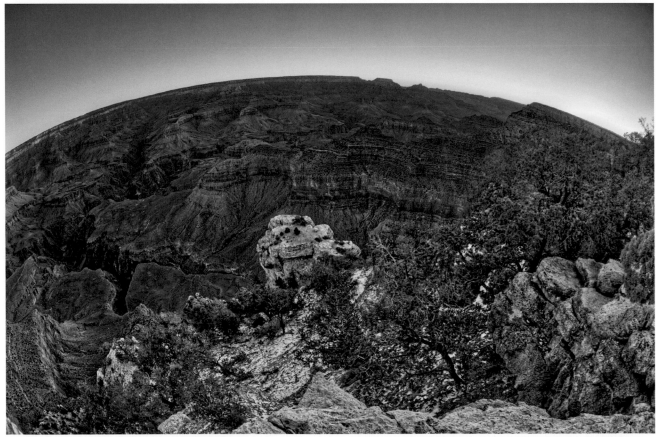

*Adding an additional -3EV exposure allowed for full capture of the narrow skyline in this compostition, HDR merged and tone mapped FDRTools.*

The image at left was taken of the Grand Canyon at sunrise with a 10.5mm fisheye lens. The camera's metering system reads a region that is 80% dark with a small bright area in the top right of the frame. The metering, and therefore bracketing, will place emphasis on exposing the 80% region properly while missing proper exposure of the rising sun. I shot three images, at –2EV, 0EV, and +2EV, plus one image at –3EV to expose for the sky, then processed all four in FDRTools and applied Curves and Levels adjustments later in Photoshop.

In the Gorman Farm image below, the reverse is true. The cameras meter reads for the bright sky, as it occupies 80% of the frame. In this case, an additional +3EV image would ensure capture of the narrow piece of land at the bottom. I shot three images, at –2EV, 0EV, and +2EV, plus one image at +3EV to expose for the land in the foreground, then merged them into a single HDR image using FDRTools.

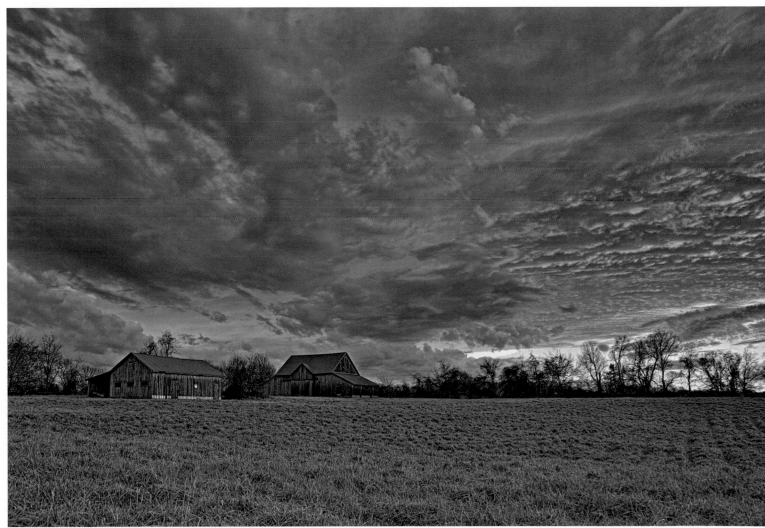

*Adding an additional +3EV exposure allowed for full capture of the dynamic range in this scene of Gorman Farm at sunset, HDR merged and tone mapped in Photomatix Pro.*

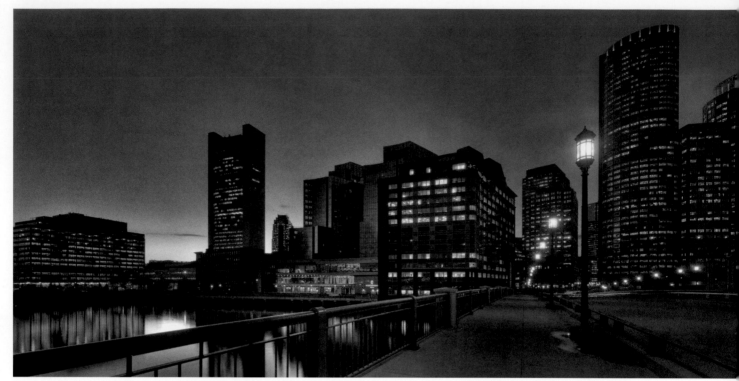

*This HDR image of the city of Boston was taken just after sunset and comprised of four images. I originally shot three images at 2EV spacing, but realizing that the camera's meter would mostly ignore the small street lamps, I added a fourth image at –3EV.*

## Creating HDR Photos from Two Images

If you are a minimalist and like the idea of keeping your image sets short and sweet, consider HDR merging with two images. Here are a few combinations that work well:

- 0EV and +2EV (for added shadow detail)

- 0EV and –2EV (to capture highlights)

- +1EV and –1EV (for greater dynamic range than a single image)

- +2EV and –2EV (for even greater dynamic range than a single image)

This technique works well for those that find single shot photography suitable to their style yet are willing to add an extra image for more options when processing. With two images, workflow and storage space is less than with a large image set, and the dynamic range captured is ample to get the results needed for low to middle contrast scenes. And keep in mind that the choice you make for the second exposure should be based mostly on scene awareness, and to a lesser extent, histogram analysis.

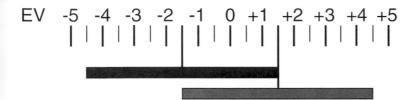

This diagram shows the overlap when two images at +1.5EV and −1.5EV are taken. The total dynamic range captured is 9EV.

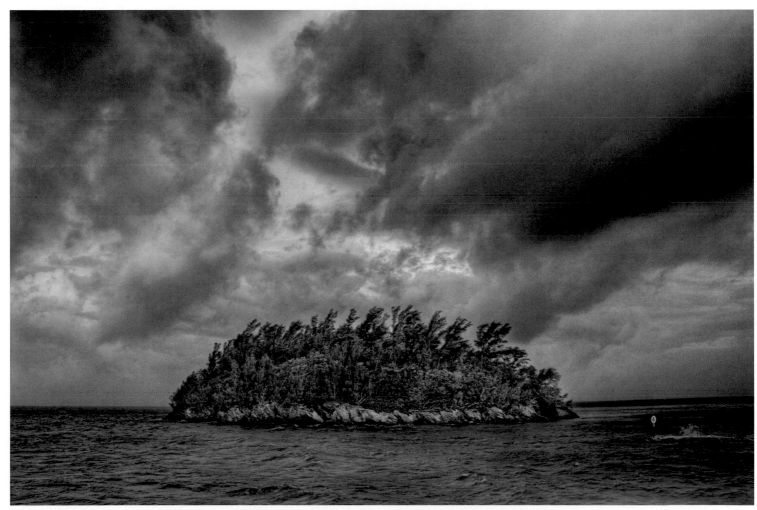

This small island next to Bermuda is an HDR image created from a two-image set. The 0EV image was taken to capture the sky and a +2EV image was taken to capture some color and detail in the island.

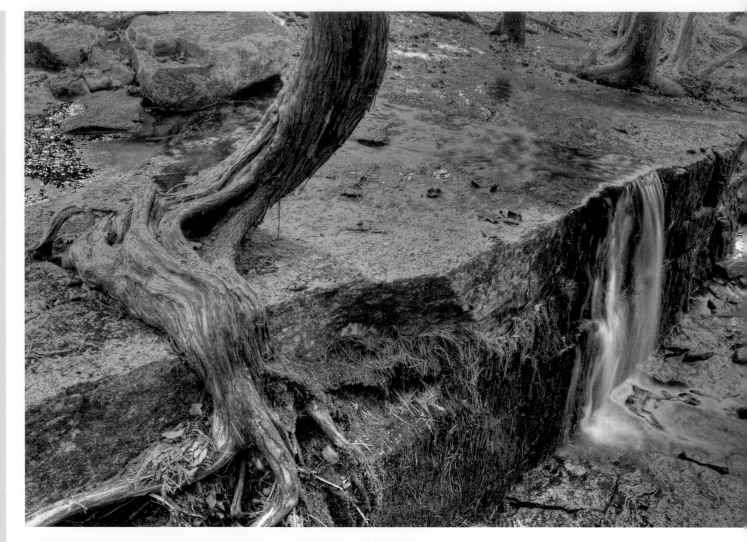

## Merging when the EV Bracket is Too Great

It is possible to take two-image bracketing too far. Too many EV steps between the frames will have the effect of adding noise, or result in blotchy areas in the final image. As you can see, a localized blotchy area appears at the top of the waterfall in the final image (left) where overexposed pixels were replaced with excessively underexposed pixels.

# Merging with Too Many Images

Merging to HDR using too many images will slow down processing, but it also carries the added risk of lower quality HDR images due to camera movement and ghosting. The goal is to merge only enough images to capture the full dynamic range of the scene. If you happen to be shooting a scene that you are unfamiliar with, or you are unsure how many shots it will take to capture the full EV range, shoot extra images for comfort. Then later, use only the ones that are needed; you might have seven frames but decide to merge only three. As mentioned previously, take enough shots to ensure that there are no blown highlights in the most underexposed shot, and that the shadow details are sufficient in the most overexposed shot. Any images that lie outside this range need not be included. In the section on histogram analysis, we will identify quality images based on histograms and eliminate those that are beyond the dynamic range of the scene (see pages 112-114).

# Noise and Number of Images

Most of the time, noise is not a problem when merging to create HDR images. However, if you are an avid HDR photographer, you will eventually tone map an image set that leaves you wondering what went wrong. Suddenly noise—those brightly-colored, randomly spaced pixels—are in every dimly-lit portion of the scene, and you notice that the single 0EV image has less noise than the image created by the magical process of HDR. Questions begin to stir. Is the EV spacing wrong? Did I take too few images, or too many? Or maybe you just chalk it up to a bad image set and move on to something new.

It comes down to one important rule: The presence of noise in the overexposed image will be enhanced and become readily visible during the tone mapping process. (Recall that the tone mapping process opens shadow details and adds local contrast enhancements.) If the scene you are shooting has high potential for noise (like a night scene, for example), it is important that the most overexposed image be noise-free in the shadow areas. Of course, noise will be present in the 0EV exposure and in the underexposed images, where it may be substantial, but a noise-free overexposure is the key to a noise-free HDR image.

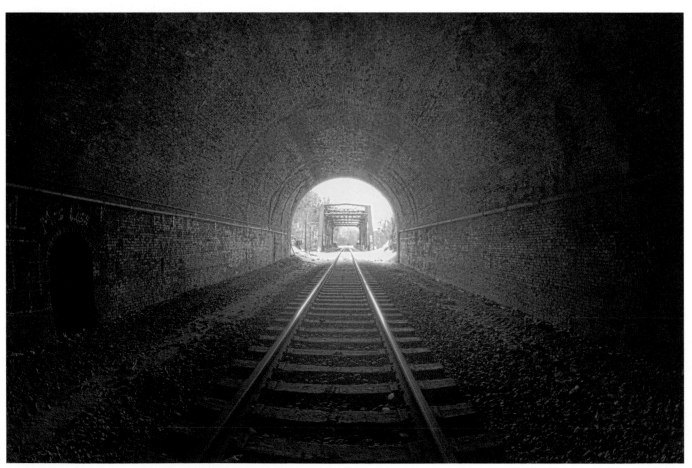

*This is the 0EV image, which as you can see has lots of noise.*

*The typical image set of three images taken at 2EV spacing doesn't even come close to capturing the dynamic range of this scene. Notice the prevalence of noise in the archway on the left side of the tunnel, as shown in this close crop*

**An Example of Noise:** The railroad tunnel scene was chosen primarily for it's high contrast so that noise could have a chance to reveal itself in the dark shadows. The wall texture and gradual change in dim lighting across the wall of the tunnel is ideal for detecting the onset of noise. Spot metering showed a 12EV range from the sky at the end of the tunnel to the small brick archway on the left. I was barely able to see my feet at this location; the glare from the tunnel opening made it nearly impossible to see texture or color (see the 0EV exposure, left).

To get what I needed to create an HDR image from this scene, I shot 28 images at 1/2EV spacing and ISO 800. In reviewing the histogram for each image, I determined that the dynamic range of the scene was captured in the images between −5EV and +5EV. The +5EV image was the most overexposed image that could provide useful information for the merging process without being redundant, and the −5EV image was the most underexposed image that could provide such useful information. Of the 28 images taken, 21 were within the dynamic range from −5EV to +5EV. The rest were beyond the dynamic range of the

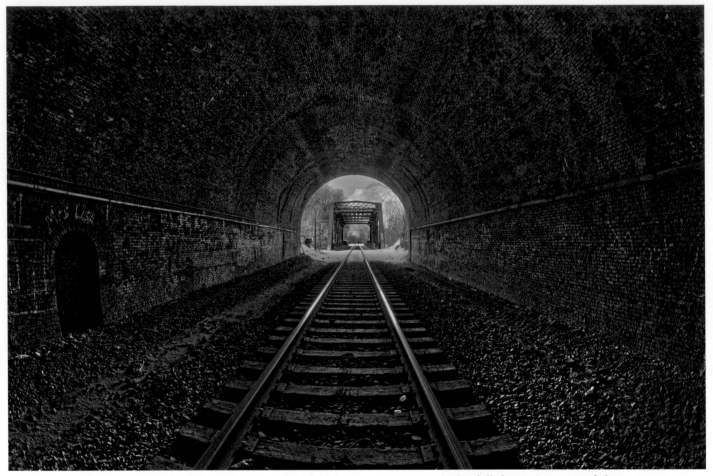

*For this subject, 11 images at 1EV spacing was the ideal image set to capture the full dynamic range of the scene.*

scene. Each image was converted to a 16-bit TIFF with zero tonal adjustments. I used FDRTools to merge the images into an HDR file, with the program's tone mapping settings left at their default values.

FDRTools handled the noise-packed images of the tunnel beautifully, and the program has excellent control of highlights and shadows. Only when image capture fell below the dynamic range of the scene did noise appear. Even at ISO 800 and in very dim lighting, it is possible to obtain relatively noise-free images when the full dynamic range is captured.

## Histogram Analysis

The histogram is probably one of the most valuable tools in digital photography. It allows you to see how the captured pixels are distributed in the scene. The horizontal line represents tonal values from 0 – 255. The black pixels are on the left, closest to 0, and the white pixels are on the right, closest to 255. As you might've guessed, the midtones are in the middle. The vertical areas of the histogram are a series of columns; each column has a height that is relative to the quantity of pixels with that tonal signature.

## Overexposed Images

Two very important roles that the overexposed image (or images) plays in HDR merging are noise reduction and increasing detail in the shadow portions of the final image. The question is, how much overexposure do you need? The ideal histogram for an overexposed image should have a tip that begins a small distance from the left side of the graph and progressively grows in volume towards the middle and right side. Ensuring that the histogram line does not touch the left hand side means that the darker tones in that exposure are noise free and have not gone to black.

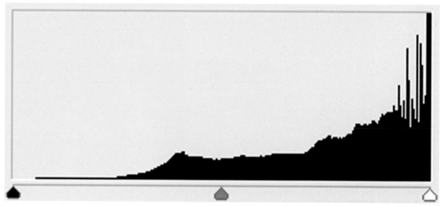

*This +2EV exposure shows the tip at the left is not touching the left side of the histogram, indicating that the shadows are not black. This is the ideal histogram for an overexposed image.*

## Underexposed Images

When shooting an image set for HDR, you might have one, two, three, or even four underexposed images. The objective of underexposure is to achieve saturated highlights. To be sure you are successful, check to see that the tip on the right side of the histogram is not touching the right side of the graph.

**Note:** The exception to this rule is when including the sun or bright artificial lighting in the scene. It's not necessary to expose for the sun's disc or aurora in most cases. Additionally, street scenes at night may have blown highlights in the "hot" center of the light.

*This −1EV exposure has its right tip moved away from the right margin, indicating that the highlights have been properly captured.*

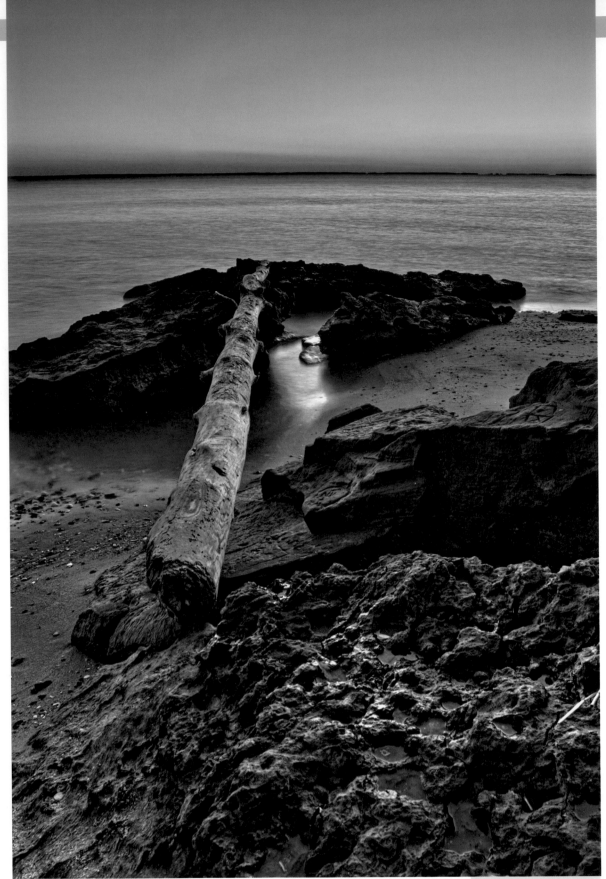

*I shot seven images at 1EV spacing in AEB mode. Then I checked the in-camera histogram of the –3EV image and saw that there were some blown highlights, so I took an additional –4EV image.*

**FDRTools – Compressor**

**Compression: 5**

**Contrast: 5**

**Smoothing: 5**

**Saturation: 1.20**

## Chesapeake Bay Sunrise

I took eight images minutes before sunrise along the Chesapeake Bay (left). I easily guessed that I needed more than three images at 2EV spacing (the workhorse image set), but it was the in-camera histograms that helped me know how many additional exposures I needed to capture the full dynamic range of the scene.

# Ghosting

Motion can be one of the biggest obstacles to obtaining high-quality HDR images. HDR photography involves taking several images of a scene, so an object in motion will be captured in a different location each time an image is taken. In the final merged image, the position of the object will appear staggered in different places across the scene. This effect is called ghosting.

Some HDR programs—such as Photomatix Pro, FDRTools and Dynamic Photo HDR—allow for ghost removal. The Photomatix Pro ghost removal function is automatic and consists of selecting either Normal or High detection. FDRTools has a very clever feature called the Separation tool to deal with motion in an image. The basic premise is that you decide the group of pixels in each image that contributes to the final HDR image. You also have an opportunity to view your work as it progresses, allowing for very efficient ghost removal. Dynamic Photo HDR has a mask-based ghost removal feature that allows you to paint a red mask on the ghosted area. Once the area is masked, the program takes it from there and decides which is the best exposure to use in the final rendering.

*The motion of the palm branches while I was shooting the source images for this HDR photo caused ghosting in the final image. The shutter speed was fast enough to stop action, but the time lapse between frames allowed the branches to move to another position. Here is the merged HDR photo with Photomatix Pro's Ghost Removal tool turned off.*

*By checking the Ghost Removal box in Photomatix Pro and following up with some minor cloning in Photoshop, the palm branches are now ghost free. (Compare this image with the one on page 115).*

Ghost removal can be quite complicated, especially when it is throughout the scene. Although software can solve some ghosting problems, not all ghost removal is possible. However, there are a few ways to mitigate the problems, some of which take place during shooting and others during image processing.

### Reduce Ghosting During Shooting

1. Use Continuous shooting mode at the highest frames per second (fps) rate.

2. Shoot fewer images, or choose fewer images to merge to HDR.

3. Set your camera's AEB bracketing order to Meter/Under/Over thus allowing the two images −2 and +2 to be shot back to back. Then, merge only those two images.

### Reduce Ghosting During Processing

1. Use the automated Photomatix Pro ghost removal feature.

2. Use the FDRTools Separation tool during merging.

3. Use the Dynamic Photo HDR mask-based ghost removal feature.

### Other Ghosting Solutions

1. Use Adobe Photoshop to clone out the ghost artifacts. Or, using Layers and Masks, blend the single 0EV image with the ghosted region.

2. If all attempts at ghost removal fail, consider tone mapping a single image from the set.

# *Valerio Popando*

**Artist Statement:** My name is Valerio Pandolfi. I was born in Naples on August 20, 1966 and was fortunate to have a father who was a photographer to teach me many secrets of the darkroom and of film photography. I also spent five years as an assistant photographer for the Sopraintendenza of the cultural assets of Naples where I had the opportunity to work with Hassleblad and large format cameras.

Learning the techniques of HDR photography has allowed me to express myself and give my personal interpretation of the world around me. I avoid excessive processing and extreme tone mapping in order to maintain a small amount of realism. I use a Nikon D80 and take 3 exposures at 2EV spacing for most scenes, but occasionally take more exposures for added dynamic range, then process in Photomatix Pro and Photoshop.

Visit http://www.flickr.com/photos/valpopando/ for more gorgeous HDR photos by Valerio Pandolfi.

www.flickr.com/photos/valpopando

© Valerio Popando

© Valerio Popando

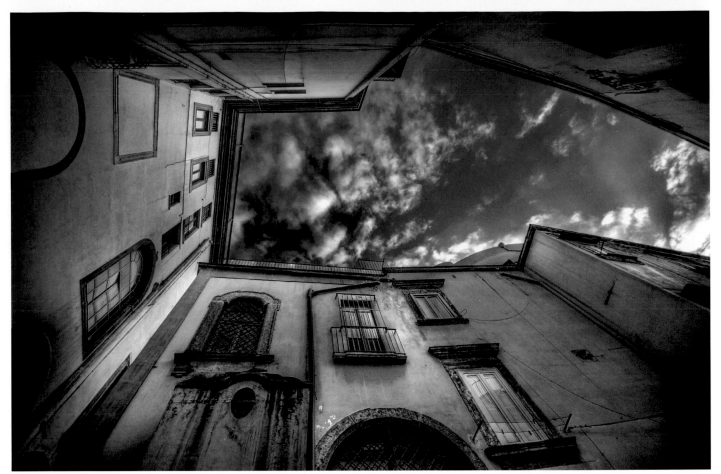

© Valerio Popando

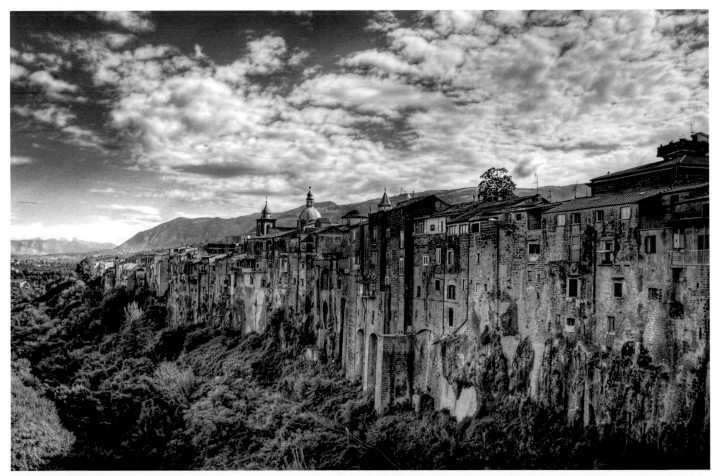

© Valerio Popando

© Valerio Popando

© Valerio Popando

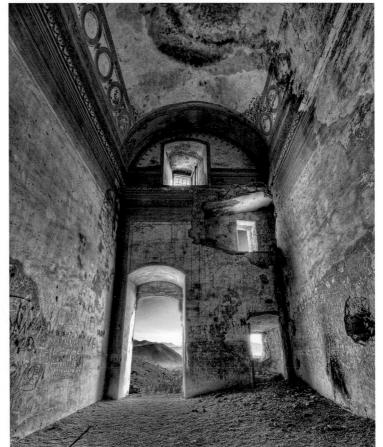

© Valerio Popando

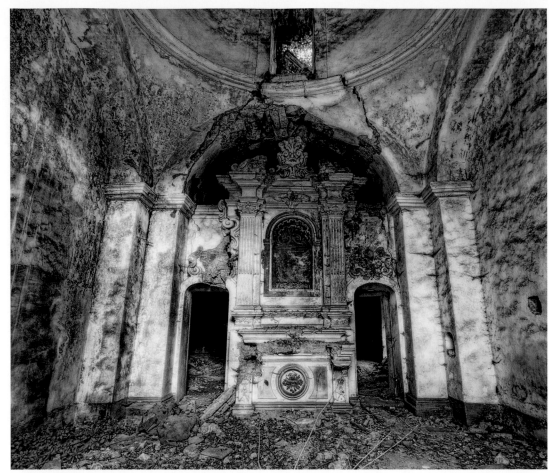

© Valerio Popando

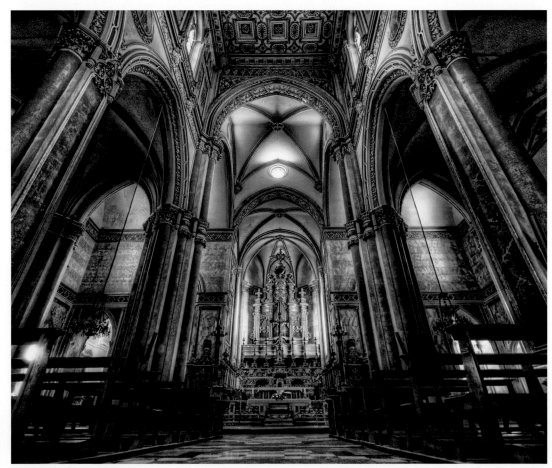

© Valerio Popando

# 6

## FLASH MERGING, ARCHITECTURE AND PANORAMAS

# Flash Merging

I'm an experimenter at heart and I enjoy trying new things. My curiosity led me to adding flash to HDR photography to see if I could obtain a successful image. I began with the flash mounted on the camera, with limited success. Then I started working with the flash detached from the camera. This is when I discovered what I call the "flash merging" technique. Flash merging is accomplished by taking a series of exposures with the flash fired from a different position for each exposure, then all the exposures are merged to HDR and tone mapped. The final HDR image represents the sum of all the illuminated parts from each exposure.

Flash merging can yield dramatic results without the need for a $3000 lighting setup. The equipment needed can vary, but that will depend on how much mobility you want with your flash unit. You can hard wire the flash to the camera and have about 15 feet of cord to move around with, or you can invest in a radio transmitter like the Pocket Wizard (www.pocketwizard.com) with a 1600 foot range.

For flash merging, the camera's exposure setting stays the same for each shot, such as 1/60 second at f/8, for example. As a result, the EXIF data for each exposure will be the same, so if the HDR merging software you intend to use to create an HDR image depends on varying EXIF data, you will run into a problem. Merging these flash merging technique exposures to HDR should only be done with an algorithm that works with luminosity of the image rather than EXIF information. Of the software covered in this book, FDRTools, Photomatix Pro, and Artizen HDR are able to create HDR images from flash merging exposures without a problem. Dynamic-Photo HDR is able to process the images, but results vary from good to unacceptable. Photoshop CS2 uses EXIF data, so you will receive an error message if you try flash merging with that program. Photoshop CS3 will merge the exposures, but some HDR images end up with unwanted artifacts.

To determine aperture and flash strength, do a few test images and check for blown highlights. Adjust the camera's distance to subject, aperture, and flash output accordingly. Some blown pixels are not a problem; remember that the HDR merging software will disregard them. Just make sure you have at least one image with proper saturation in that part of the scene.

Of all the software programs I tested for use with my flash merging technique, Photomatix Pro gave the most consistent high-quality results. The Highlights and Shadows – Adjust feature created a remarkably uniform blend. I was even able to test flash merging on a scale as large as a multi-room home interior with results that paralleled a full studio lighting set up.

### Flash Merging Quick Tips

• Use ISO 100 if possible

• Use a tripod and a cable release

• Use self-timer function to allow for positioning the flash

• Set camera to manual focus

• Set camera to Manual exposure mode and expose for flash photography (i.e., 1/60 second at f/8)

• Use the widest aperture that your desired depth of field will allow

• Set the flash to manual mode and fire it at the highest output

• Set white balance to Flash or do a custom white balance

• Identify potential shadows created with each flash and fill them in with additional exposures

• Don't worry about hot spots (overly bright areas) created by the flash; the HDR merging process corrects them

The number of images to take of a given scene is entirely dependent on the size of the subject. Each exposure will have its own unique single source lighting. Be conscious of shadows and highlights for each flash and direct each flash to fill in what the other doesn't provide. Larger subjects require more exposures to obtain full surround lighting, but even small subjects need about five exposures. Once a scene is set and you're ready to shoot, it's much easier to take a few extra exposures to ensure you get what you need to create a great HDR image. You can always eliminate the exposures you don't need later.

*I shot six source images, each with a different flash location, then processed them in FDRTools using the Creative merging method.*

*Once merging is complete, you can choose any tone mapping operator. I used Tone Compressor for this image.*

*I processed these five source images in Photomatix Pro using Highlights and Shadows – Adjust. Remember that RAW files have to be converted to 8-bit TIFF or JPEG before using this merging algorithm. The Blending Point controls which image has the greatest influence over the final look. The Radius slider increases the sharpness of the image.*

*Here is the final flash merged HDR image.*

*I shot six source images with six different flash locations for this scene.*

*The final flash merged HDR image was created in Photomatix Pro using the Highlights and Shadows – Adjust merging tool. Care was taken to fill each shadow with flash so that it wouldn't appear in the final merging.*

I blended five source images in Photomatix Pro using the Highlights and Shadows – Adjust merging tool. The time shows both 2:33 and 2:34 in the source images, but the Blending Point slider allowed the selection of 2:34. No post processing was required.

Complete Guide to High Dynamic Range Digital Photography

Here is the final flash merged HDR image.

## Using Gels

When different colored gels are placed on the flash from shot to shot, each image will contribute a different color to the final merging. In the image above, four images were merged in FDRTools using Creative merging and tone mapped using Simplex. One off-camera flash on maximum power was used with a Pocket Wizard radio slave. I maintained a distance of 5 – 10 feet between the flash and the subject. The shutter speed was 1/160 second, which allowed flash exposure but not ambient light. Thus, the scene appears as if it was taken in darkness.

*I shot four source images of this scene using different colored gels placed on the flash.*

*This is an interior scene with windows. It is properly exposed for the room space, but areas around the window have become over saturated and have blown highlights. The dynamic range is so great, even the lampshade near the window has lost detail. Had I used several flash units, I would have to deal with careful positioning and power output. I would need to watch for hotspots and crossing shadows from the legs of the table in order to capture a natural look.*

# Architectural HDR Photography

The demand for photographs of interiors is tremendous. Restaurants, hotels, and tourist attractions need to advertise. Even local shops and offices need interior photography for brochures and records. In addition, manufacturers of home goods from furniture to kitchen appliances want to advertise their products in their natural setting.

The biggest problem for photographers entering the profession of interior photography is lighting. It's not so much about the proper lens or the best camera to use, but more about how to control the light throughout the room. Whether it's the bright streaks of sunlight through the window or dark shadows in corners and under cabinets, the difficulty remains; the range of light must be captured and look natural. After all, clients want the pictures to look as if the eye is seeing it.

Traditional photography setups for interiors include a wide array of lighting equipment and the use of medium format cameras. Not only is the initial investment substantial, it takes years to master the lighting ratios and numerous combinations of lighting setups. It's no surprise that few photographers have entered the field of interior photography. So herein lies the question: Can HDR photography close the gap by offering images that suit clients' needs using with relatively little lighting equipment? It certainly can.

The most important thing to focus on for the aspiring architectural interiors HDR photographer is realism. Excessive tone mapping should be avoided, as should flatness in the image. The final tone mapped image may require blending with one or several of the single source images to create a natural feel.

In situations where the interior space has windows to the outside, the dynamic range can be very high. To properly capture the full dynamic range, shoot seven or nine exposures at 1EV spacing, or 5 exposures @2EV spacing. It is also important to check the in-camera histogram to confirm that the highlights aren't blown and the shadow details are properly exposed.

*The HDR image of the scene, on the other hand, is well exposed with open shadows and controlled highlights. Overall, the image is warm, rich in appearance, and inviting. I created it by taking seven exposures at 1EV spacing, and merged them using FDRTools Compressor.*

*This scene is dimly lit. The shutter speeds are long enough that the cars are not seen, but rather only their head-lights as they drive past the building.*

*Just as in all forms of photography, timing can be the most important factor in getting a good pic-ture. This building is front-lit, the moon is out, and sunset is in progress. A recent rain shower left the parking area wet, so a nice reflection was present. To create the HDR image, I merged and tone mapped five source images at 1EV spacing in Photomatix Pro with the Details Enhancer operator.*

Traditional photography setups for interiors include a wide array of lighting equipment and the use of medium format cameras. Not only is the initial investment substantial, it takes years to master the lighting ratios and numerous combinations of lighting setups. It's no surprise that few photographers have entered the field of interior photography. So herein lies the question: Can HDR photography close the gap by offering images that suit clients' needs using with relatively little lighting equipment? It certainly can.

The most important thing to focus on for the aspiring architectural interiors HDR photographer is realism. Excessive tone mapping should be avoided, as should flatness in the image. The final tone mapped image may require blending with one or several of the single source images to create a natural feel.

In situations where the interior space has windows to the outside, the dynamic range can be very high. To properly capture the full dynamic range, shoot seven or nine exposures at 1EV spacing, or 5 exposures @2EV spacing. It is also important to check the in-camera histogram to confirm that the highlights aren't blown and the shadow details are properly exposed.

*The HDR image of the scene, on the other hand, is well exposed with open shadows and controlled highlights. Overall, the image is warm, rich in appearance, and inviting. I created it by taking seven exposures at 1EV spacing, and merged them using FDRTools Compressor.*

*This image con-
sists of seven
images at 1EV
spacing, plus one
additional under
exposed image at
−6EV. All eight
images were
processed in
FDRTools, then I
made minor
adjustments using
Curves and Levels
in Photoshop.*

Many interior settings consist of a dimly lit
room with a bright window. This creates a
scene of high contrast, and if the window is
small relative to the overall composition, the
camera can incorrectly meter the window
area. (Recall our discussion on scene aware-
ness on pages 103−105.) There are a few
options available. The first option is switch to
spot metering and meter for the bright area
and then progressively add overexposed
images until the full dynamic range is cap-
tured. Checking the histogram of the most
overexposed image is very helpful with this
option. The second option is to take an AEB
image set then add some additional underex-
posed images to ensure proper exposure of the
window light. This latter method may require
seven exposures at 1EV spacing followed by
two additional underexposed images, one at
−4EV and one at −5EV.

White balance can be a challenge when pho-
tographing interior architecture. Incandescent
light is mixed with daylight, and the color
temperatures are 3000K and 5200K, respec-

tively. Splitting the difference in color temper-
ature and exposing at 4200K is an option.
However, many interiors benefit from the
added warmth of the incandescent lighting,
thus a setting over 4200K works well. If you
are shooting RAW files, getting white balance
exactly right during shooting isn't as much of
a priority, as it can be changed in post pro-
cessing. Those who shoot JPEGs should
always preset the white balance very carefully
in-camera, though.

HDR photography offers the benefit of bring-
ing the outdoor scene into the room. In the
case of the planter box and deck outside the
window in the top right image, this is certain-
ly an advantage. However, creating a sense of
light filling the room also has its advantages.
For example, the outdoor scene in the dining
room image (bottom right) is uninteresting and
serves no added benefit by being well-exposed.
By increasing the white point to 5% and adding
Highlights Smoothing in Photomatix Pro, the
distracting details outside disappear and the
increased light across the buffet table eliminates
the feeling of being in a cave.

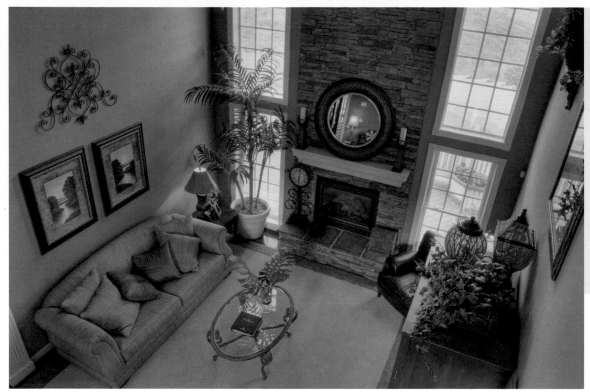

Photomatix Pro – Details Enhancer

Strength: 70

Color Saturation: 50

Light Smoothing: High

Luminosity: 4

Micro-contrast: –1

Micro-smoothing: 6

White Point: 0.00%

Black Point: 0.00%

Photomatix Pro – Details Enhancer

Strength: 50

Color Saturation: 50

Light Smoothing: Medium

Luminosit: 5

Micro-contrast: –1

Micro-smoothing: 6

Highlights Smoothing: 25

White Point: 5%

Black Point: 0.00%

*This scene is dimly lit. The shutter speeds are long enough that the cars are not seen, but rather only their headlights as they drive past the building.*

*Just as in all forms of photography, timing can be the most important factor in getting a good picture. This building is front-lit, the moon is out, and sunset is in progress. A recent rain shower left the parking area wet, so a nice reflection was present. To create the HDR image, I merged and tone mapped five source images at 1EV spacing in Photomatix Pro with the Details Enhancer operator.*

*One of the distinct advantages of HDR photography is capturing the full dynamic range of light in large interiors where flash equipment is not feasible. Here, at the National Cathedral in Washington, DC, you are allowed to move about freely with camera and tripod, but detached studio lighting is not allowed.*

Low light outdoor architectural photography requires an awareness of man-made lighting. If the lights are small in the composition, there is a good chance the camera's metering system won't account for them, resulting in the lights and the areas around them being blown in the image. A good practice is to add an under-exposed image to capture the lights themselves and the immediate area surrounding them.

## Flash Merging and Interior Architecture

Applying the flash merging technique for an interior is a viable alternative to exposing for existing light and merging to HDR. Simply stand beyond the view of the lens and fire the flash into dimly lit areas of the room. For a home interior, I usually take three to seven flash exposures and merge them in Photomatix Pro using Highlights and Shadows – Adjust, with excellent results. For the real estate photographer, flash merging is less intrusive (and less expensive) than a complete studio setup, and it offers good color accuracy and controlled white balance (5200K).

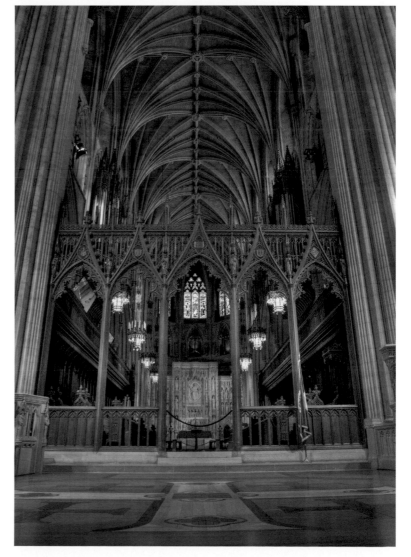

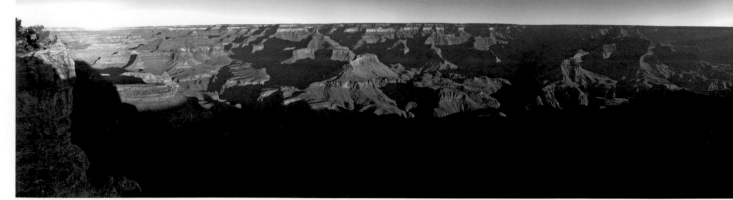

*Grand Canyon, Arizona: Here is the single 0EV image set stitched in PTGui panoramic stitching software. Shadow and highlights adjustments were made in Photoshop CS3 to improve overall exposure.*

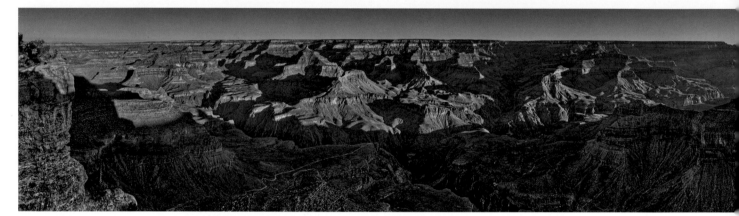

*This HDR image was created in FDRTools by first merging five exposures at 1EV spacing for each image in the panoramic set (of which there were eight), then stitching those eight HDR files together into a panorama using PTGui panoramic stitching software. Once stitched together, I tone mapped the HDR panorama in FDRTools using the Compressor tone mapping operator.*

# Panoramic HDR Photography

Digital panoramic photography is the process of taking a series of overlapping images and using software to "stitch" the images together to produce one long or tall picture of a scene. HDR photography offers a viable solution for dealing with extreme lighting conditions for panoramic photography. On a sunny day, for example, you may be shooting directly into the sun in one section, followed by a few side-lit and front-lit shots. Instead of taking single images, try creating an HDR image for each section of the panoramic set. Take a bracketed image set at each camera position to allow for control of the highlights and shadows. That way, each image set has the potential for capturing the full dynamic range of that panoramic section.

# HDR Panorama Workflow

Efficient workflow has always been something to strive for when building a panorama, and adding the HDR element means that an organized and efficient workflow is more important than ever. Not only do you need to stitch the images together to form the panorama, but with HDR you need to merge and tone map each section of the panorama. There are three basic ways to approach the workflow for HDR panoramas. It comes down to asking yourself when you want to stitch the images together in relation to merging and tone mapping.

| Method | Description | Stitching Software |
|---|---|---|
| Stitch* > Merge > Tone Map<br><br>*Stitch first | 1. Stitch each exposure set into a panorama (i.e., all the 0EVs into one, all the -1 EVs into another, etc.)<br><br>2. Merge the panoramas into a single 32-bit HDR file.<br><br>3. Tone map the HDR image. | This method can be achieved with the following panoramic stitching programs: Autopano Pro, PTGui, and Panorama Factory. Workflow can be awkward, especially when merging large panoramas. |
| Merge > Stitch* > Tone Map<br><br>*Stitch second | 1. Merge each section of the panorama into a 32-bit HDR file.<br><br>2. Stitch the 32-bit HDR files together.<br><br>3. Tone map the HDR image. | The following panoramic stitching programs can read and stitch 32-bit HDR files: Hugin, APP, PTGui, Realviz, and Stitcher. The results are excellent. |
| Merge > Tone Map > Stitch*<br><br>*Stitch last | 1. Merge each section of the panorama into a 32-bit HDR file.<br><br>2. Tone map each HDR image.<br><br>3. Stitch the HDR images together. | This is the familiar HDR process covered throughout the book, followed by stitching of the individual tone mapped images. All the stitching programs can do this. |

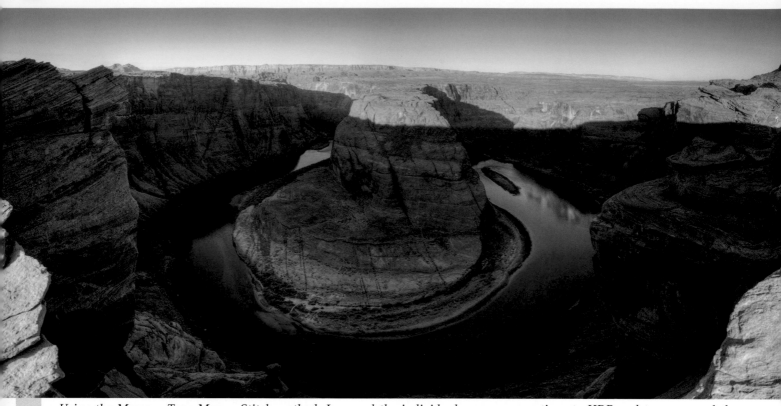

*Using the Merge > Tone Map > Stitch method, I merged the individual panorama sections to HDR and tone mapped them in Photomatix Pro using the default setting in the Details Enhancer operator, then stitched them together in Autopano Pro.*

## Merge > Tone Map > Stitch

Of the three possible methods for creating HDR panoramas, this is the one I prefer to use. The workflow is familiar, and I have the option of using a section of the panorama as a stand-alone tone mapped image if I choose. A possible downside to stitching tone mapped images, however, is that the tone mapping process may create contrast and color variations in each section causing poor blending in the stitched results. This can be avoided by opening several sessions of the HDR program and arranging the separate image windows as if they are stitched then tone mapping each section to match the adjacent one.

**Hint:** If you have more sections than you can reasonably open and tone map at once, then just tone map the critical sections of the image simultaneously to establish a good overall consistency. For example, focus on the areas that have the highest dynamic range, or those that might be sensitive to high compression and cause halos.

***Note:*** Images created using this HDR panorama method tend to have more contrast than those created with the other two methods, particularly if you apply black and/or white clipping adjustments in each tone mapped section.

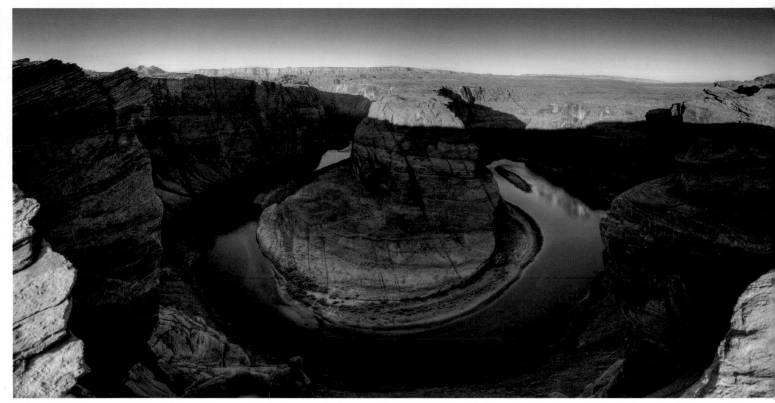

*Using the Merge > Stitch > Tone Map method, I merged the 32-bit HDR images in Photomatix Pro, stitched them in Autopano Pro, then reloaded the file into Photomatix Pro and tone mapped using the default settings in Details Enhancer.*

## Merge > Stitch > Tone Map

If the results of stitching last are not what I had hoped for, my second choice is to try the Merge > Stitch > Tone Map method. This approach can yield very good results, but before you go this route, be sure to check with the panoramic stitching software manufacturer to see if the program you have is capable of stitching 32-bit images. Stitching programs that stitch HDR files benefit from the absence of blown pixels and noisy regions in the HDR file. This method works well when the image set includes many exposures, and/or if you plan on employing some heavy-handed tone mapping.

**Hint:** Avoid over-zealous tone mapping and be aware of trouble areas that can produce halos. Large smooth regions of uniform color in an image can be problematic when tone mapped then stitched.

**Hint:** It's good practice to check the alignment of the 32-bit file before stitching. Just open it in the tone mapping window and zoom in for a closer look.

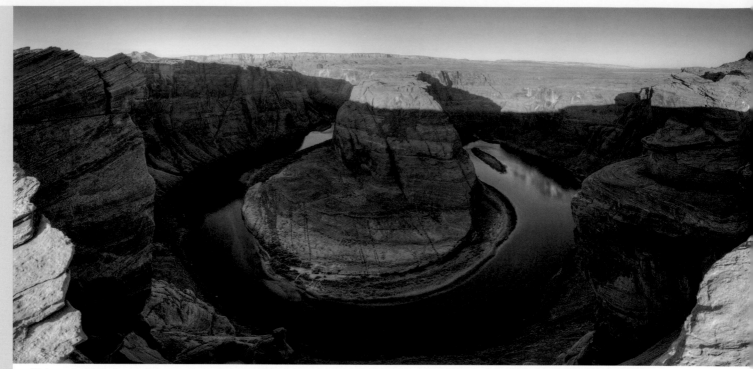

*Using the Stitch > Merge > Tone Map method, I stitched the various panorama exposures together in Autopano Pro, then merged and tone mapped them in Photomatix Pro using the default settings in the Details Enhancer operator.*

## Stitch > Merge > Tone Map

I don't routinely use this stitch first method. However, programs like Autopano Pro and PTGui have a fully automated process that allows for easy loading, sorting, and stitching of all the images in one step. There are two possible problems with this; first, the stitching program can have difficulty identifying similar features in the most overexposed images. Second, alignment problems cannot be identified until after tone mapping is complete, and it's often difficult to determine where the problem lies, in the stitching or in the HDR alignment.

**Note:** When merging stitched exposures in FDRTools, each layer has an alpha channel that needs to be deleted. The alpha channel is a transparent layer used for finding holes in the panorama after stitching. FDRTools looks for the three RGB channels and will not open the files if an alpha channel is present. Open the channels palette in Photoshop and delete the alpha channel.

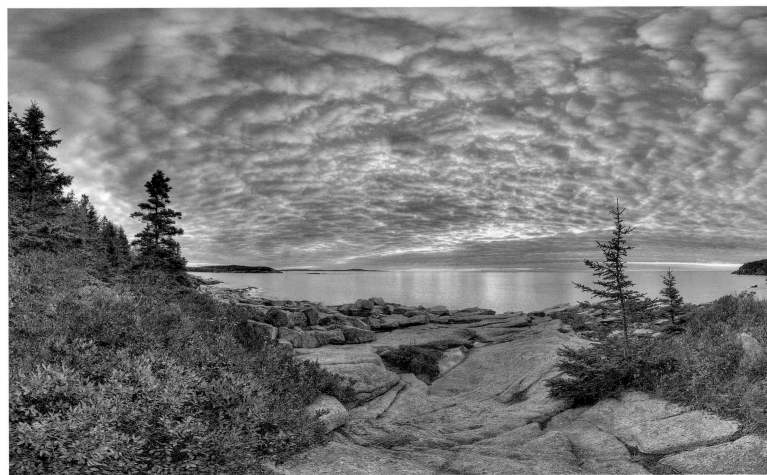

*I shot this panorama in Acadia National Park in Maine. I took five exposures at 1EV spacing in each of three positions, then processed to the images using my favorite method for construction panoramas: Merge > Tone Map > Stitch.*

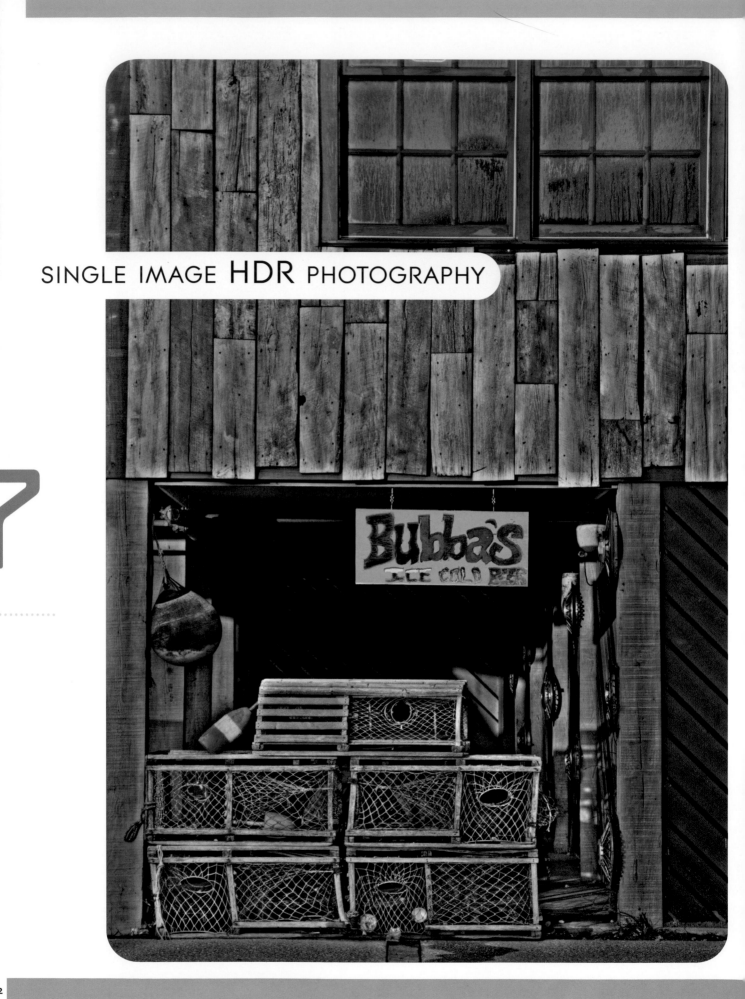

# SINGLE IMAGE HDR PHOTOGRAPHY

7

# Single Image Tone Mapping

S ingle image tone mapping can be done with TIFF, JPEG, and RAW files. Technically, it's not true HDR imaging, but if the camera sensor has captured the full dynamic range of the scene, this pseudo-HDR technique can look identical to HDR.

Compared to merging several exposures to HDR, single image tone mapping offers reduced processing times, saved disk space, and a less intensive workflow at the scene and in the computer. Combine that with ghost-free images and you could say that tone mapping single images gives you the biggest bang for your buck. As we will see, capturing the full range of light without clipping the highlights or shadows is critical to the success of single image tone mapping. Consequently, the choice to shoot a single image rather than an HDR image set should be based on the contrast of the scene. A low contrast scene is easily captured and tone mapped with a single image, but a medium contrast scene can go either way in terms of quality. Noise will be present in the medium contrast scene, but if it is fairly insignificant in the overall image, it is usually acceptable. If the scene is high contrast, shooting an HDR image set is recommended for a quality image.

The biggest shortcoming of single image tone mapping is that it enhances any noise present in the image. However, a few precautions beforehand can go a long way in minimizing the noise that often ruins an image.

- Shoot RAW files.

- Ensure proper exposure, perhaps even slightly overexposing to capture as much shadow detail as possible (but watch out for blown highlights). You may even consider setting exposure compensa - tion to +1/3 or +1/2EV.

- Use in-camera noise reduction features when available.

- Process the image in a high-end RAW converter and reduce color noise before tone mapping. In the Photoshop CS3 Camera RAW plug-in, there are sliders for Noise Reduction, Luminance, and Color Noise Reduction.

- Unlike pre-processing HDR source images, applying tonal adjustments in the RAW converter for single RAW images you intend to tone map can and should be done. Exposure settings can be used to recover highlights that would otherwise not be recovered during tone mapping. The Photoshop CS3 Camera RAW plug-in has two additional sliders that are useful: Recovery and Fill Light. (Be sure to zoom in and check edge details when using them.)

- After RAW conversion of your single source file, save the image in 16-bits per channel. They are better to tone map than 8-bit files.

**Hint:** I prefer to take five images at 1EV spacing rather than three images at 2EV spacing because the −1 and +1 exposures are then available for single image tone mapping. I routinely open the +1EV in my RAW converter, lower the exposure to recover highlights then save it as a 16-bit TIFF for tone mapping.

## Photomatix Pro

Photomatix Pro allows you to tone map a single exposure as long as it's a RAW file or a 16-bit image file. If you have a JPEG image (which is 8-bit), it will need to be converted to a 16-bit file before tone mapping. There are two methods to begin tone mapping in Photomatix Pro:

1. Go to File > Open to load the 16-bit image or RAW file, then go to HDR > Tone Mapping to open the tone mapping dialog box. (This streamlined method does not involve saving a 32-bit HDR file to your hard drive.)

2. Select Automate > Single File Conversion and check the box From Low to High Dynamic Range to convert the RAW or 16-bit image to a 32-bit HDR file. You can choose a folder for batch processing or a single file for a single conversion to HDR. Click Run and the 32-bit HDR file(s) will be saved to your hard drive. Go to File > Open to retrieve the HDR file, then HDR > Tone Mapping to begin tone mapping.

## Comparing Images

The following are a series of HDR images, single tone mapped images, and just plain single images with no tone mapping processed in Adobe Camera RAW for comparison.

The picture of the archway at Princeton University, taken during overcast skies, is well suited for single image tone mapping. The HDR image (A) is indistinguishable from the single tone mapped image (B), and further shows that shooting an HDR image set in low contrast conditions is not necessary. The Adobe Camera RAW image (C) is acceptable, but has less impact as it lacks local contrast enhancements.

*This HDR image was created using FDRTools. I merged two images, 0EV and +2EV, and tone mapped using the Compressor operator.*

*Here is a single tone mapped image, processed in FDRtools using the Compressor operator.*

*This is the original RAW file with basic processing applied using Adobe Camera RAW and no tone mapping.*

Complete Guide to High Dynamic Range Digital Photography

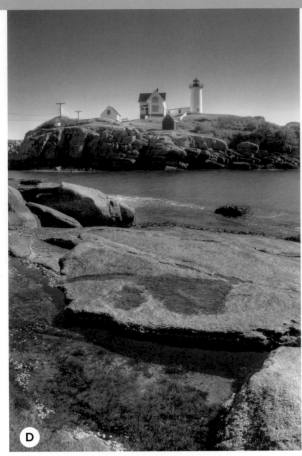

*Here is the HDR image of Nubble Point.*

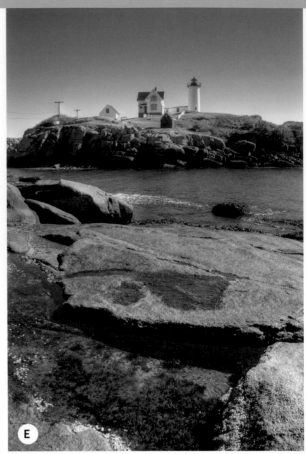

*This is the single tone mapped version of the Nubble Point image.*

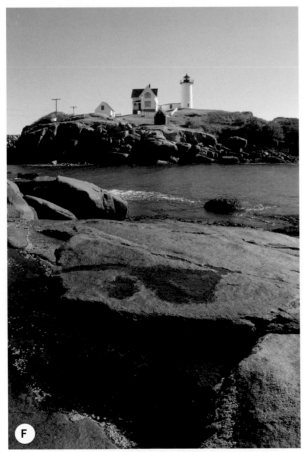

*This is the original RAW file, processed with Adobe Camera RAW and with no tone mapping applied.*

A typical medium contrast scene has about a 7 – 8EV range and is near the upper limit of the camera's sensor. If your camera is set on a low ISO, a side-lit scene on a sunny day can be captured with limited problems in a single image as long as exposure is correct. Nubble Point Light was photographed during the late morning on a sunny day. The scene is side-lit and some of the rock faces are in shadow although shadows are not a dominant part of the scene.

The HDR image (D) is the overall winner when it comes to shadow detail, but if shadow detail were not an issue, I would give the nod to the single tone mapped image (E), which has no ghosting and good color and contrast enhancements. The Adobe Camera RAW image (F) has less punch and vibrancy than the other images and, comparatively, appears unfinished.

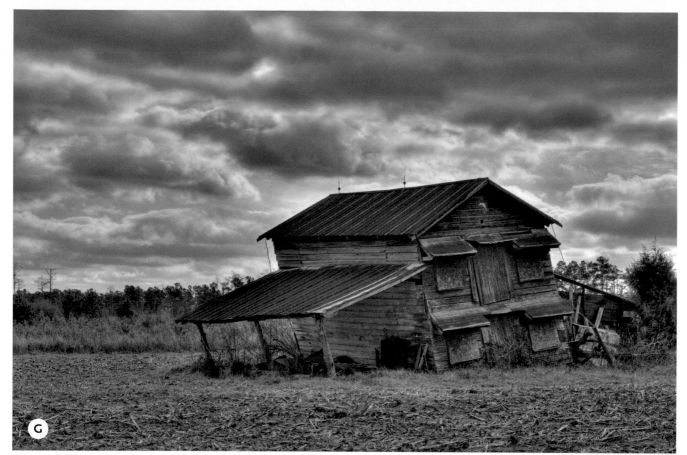

*This is the HDR image version of the barn.*

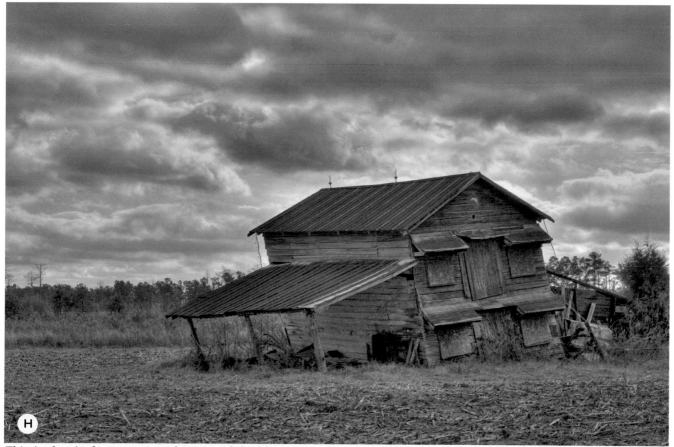

*This is the single tone mapped image of the barn.*

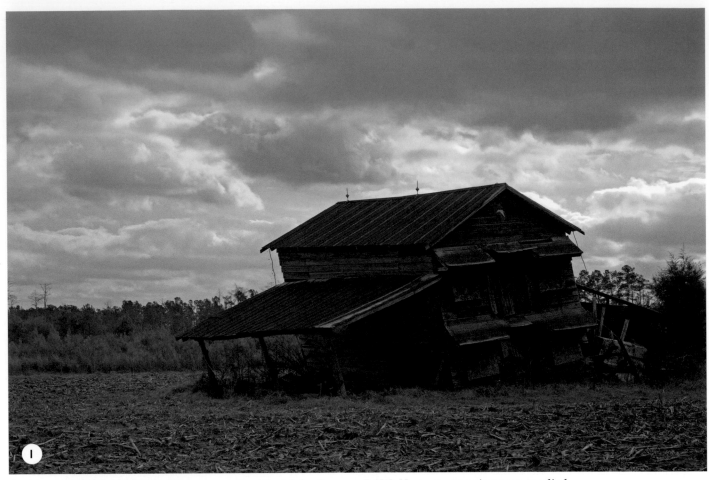

*And here is the basic RAW file, processed with Adobe Camera RAW. No tone mapping was applied.*

Photographers are often drawn to old buildings; the more dilapidated, the better. I'm not sure if we are drawn to their paint-peeling beauty, or we just like to shoot in a place where no one will bother us. This tilted barn scene had me slamming on the brakes and making a u-turn. The clouds were great, and the barn was in an open field. Considering that this was a medium contrast scene, it was hit or miss as to whether a single tone mapped image would be a good bet.

The HDR image (G) has the best shadow detail, the best local contrast, and the best overall look. The area under the roof in the HDR image also has more detail than either the single tone mapped image (H) or the Adobe Camera RAW image (I). In this case, the single tone mapped image shows a significant loss of detail due to noise, and because of this, would not be a good first choice. The

Adobe Camera RAW image (I) is comparatively flat and uninteresting despite lengthy tweaking using Levels, Shadows and Highlights, Curves, and Saturation.

The sunrise at Acadia National Park has a 9EV dynamic range as the sun begins to come over the horizon. This is a high contrast scene, and it's clear that the HDR image (J) has out performed the other two image examples in this comparison. Shadow detail and noise control are superior in the HDR image, and the overall impact is greater. There is some chromatic aberration that could use follow-up processing, but for the most part, image processing is complete. The single tone mapped image (K)

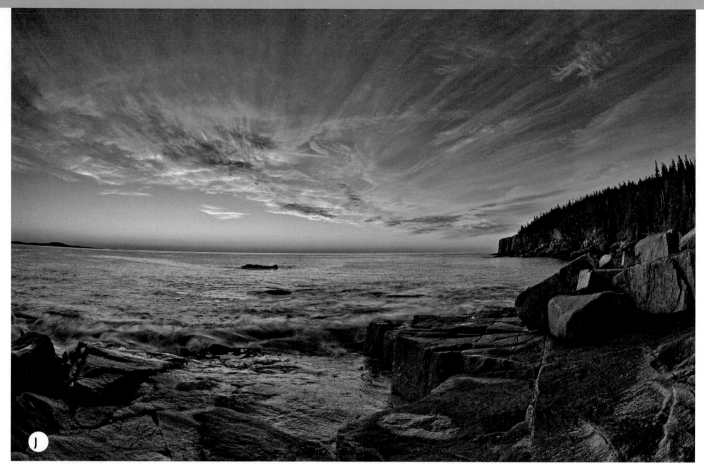

*Here is the HDR image version of the Acadia sunrise.*

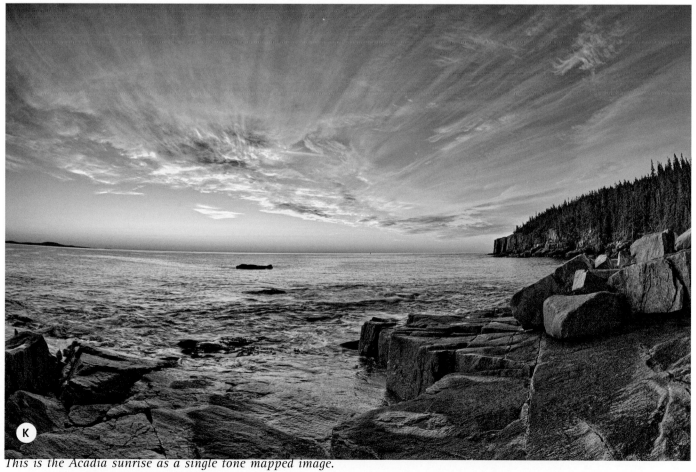

*This is the Acadia sunrise as a single tone mapped image.*

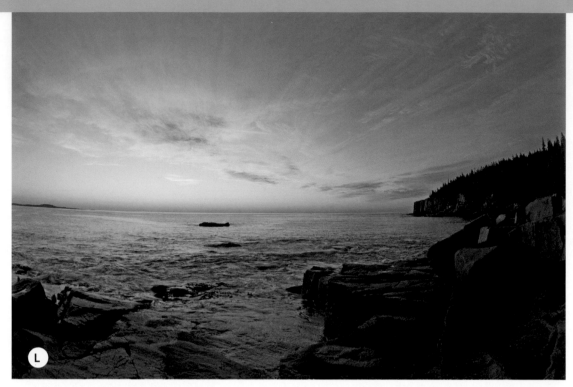

*And here is the basic RAW file of the Acadia sunrise scene, processed with Adobe Camera RAW and with no tone mapping applied.*

has lots of color noise, but otherwise has a similar look to the HDR image; it would likely benefit from applying noise reduction tools prior to tone mapping. Remember, though, that even the best noise reduction software won't be able to render the image with the same detail that HDR can. Noise prevents details from being captured, so even the best noise reduction tools cannot restore missing details. The Adobe Camera RAW image (L) lacks the brilliance and vibrancy of the HDR image. The shadows lack detail and the sky has a softer appearance without the local contrast enhancements.

Had it not been for the butte on the right acting as a reflector, the side lit scene of the Coyote Butte on page 151 would probably qualify as medium contrast. As it is, though, the single tone mapped image (N) has blown highlights, and no amount of processing will recover them. In this case, single image tone mapping is not an effective replacement to HDR photography. As you can see, the HDR image (M) captured the full range of light present at the scene. The Adobe Camera RAW file is an uninspiring image (O) with blown highlights, destined for the recycle bin.

Don't assume that all single-shot images can be successfully tone mapped. The overall success is closely tied to the contrast of the scene:

• Low Contrast Scenes – Quality is nearly identical between the single tone mapped image and the HDR image. There is little reason to shoot multiple images for HDR creation when dealing with a low contrast scene where the full range of light can be captured in one image.

• Middle Contrast Scenes – The HDR image shows an improvement over the single tone mapped image in most cases, and your decision to use one technique over the other should be based on the scene's potential for noise. HDR photography becomes particularly beneficial when the noise covers large regions in the image, or effects the detail rendition of the main subject.

• High Contrast Scenes –HDR images will show a substantial improvement over tone mapping a single image in all cases. Tone mapping a single image will result in the significant enhancement of any noise present.

*This is the HDR rendition of Coyote Butte.*

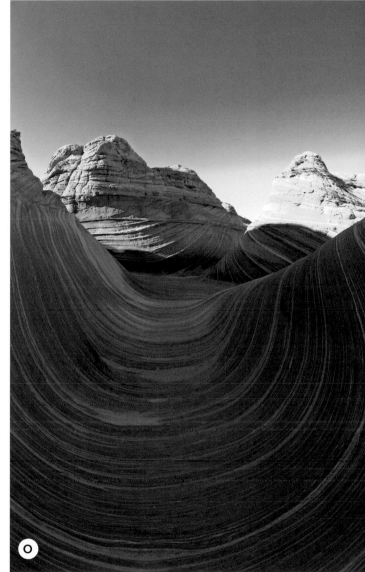

*This is a basic RAW file of the scene, processed with Adobe Camera RAW, and with no tone mapping applied.*

*Here is a single tone mapped image of the Coyote Butte scene.*

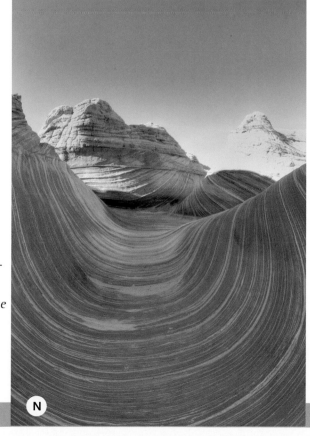

# Graduated ND Filters vs. HDR

I have done quite a bit of both graduated ND filter photography and HDR photography, and I find HDR photography to be the better choice for most shooting situations. HDR photography is not dependant on the scene like graduated ND filter photography is, and that is probably it's biggest advantage for me. Trees, buildings, irregular horizons, and even windows are easily captured using HDR techniques. After my first two weeks of shooting HDR image sets, it became part of my routine, enough so that the thought of using graduated ND filters seemed primitive.

The HDR workflow is all contained within the camera; there is no fumbling with filters, rings, and brackets. There is no need to carefully adjust filter positions and then worry about additional flare. Both choices open shadow details and retain highlights, but HDR photography allows more diversity in tone mapping and subsequent blending of various exposures. So even in situations where the filter would work fine, I still find myself opting for the HDR image set. That said, let's explore some of the differences between the two ways of shooting.

Graduated ND (neutral density) filters have been used by outdoor photographers for many years as the primary way to bring an overly bright part of a scene into the dynamic range of the recording media, be it film or digital sensor. The graduated ND filters actually filter the bright light before it gets to the lens, compressing the dynamic range and creating a high dynamic range image in a single exposure. They are ideal when the landscape composition includes a bright sky and a dimly light foreground.

Hold a graduated ND filter up to the light and you will see a clear portion that grades into a tinted portion. A short gradient is called a hard filter and a long gradual gradient is called a soft filter. The filter is designed to hold back the bright light so that your camera sensor can properly expose the rest of the scene. The soft filter is suitable for scenes with irregular boundaries, such as trees reaching into the sky. The hard filter is suitable for scenes with a well-defined, nearly straight boundary, such as where the ocean meets the sky. These filters slide into a square holder that mounts on the front of the lens. The filter can slide up or down to be positioned based on the landscape composition being photographed.

Both hard and soft filters come in strengths or stops of light they hold back. Typical ranges are from one to four stops. Ideally, the filter you choose should be based on the dynamic range of the scene, meaning that having more than one graduated ND on hand is preferred. Keep in mind that a soft gradient filter only gives the full rated filtering at the very edge of the filter, which is the part that is not used. So a 3-stop soft graduated ND filter really only holds back about 2 stops of light except for at the very top edge.

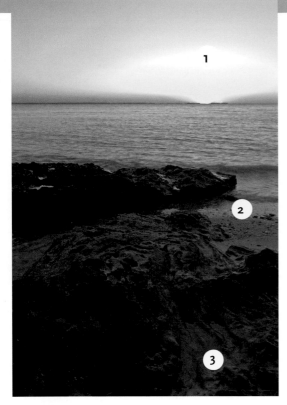

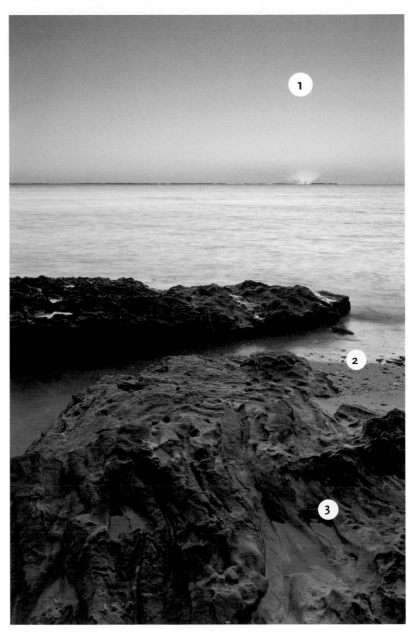

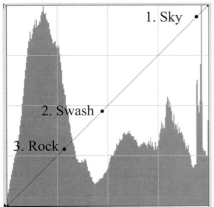

*Here is a single image taken at −1EV, and its histogram.*

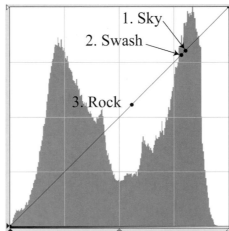

Three different images were taken at sunrise and compared. The first image (top), is the best conventional single exposure of the scene, taken at −1EV. It has blown pixels in the sky and lacks shadow detail in the foreground. As expected with shooting a backlit scene, the dynamic range was more than the camera sensor could handle. The second image (right) is also a single exposure, but two graduated ND filters were stacked to hold back the light from the rising sun and capture

*Here is the same image captured with a 3-stop soft graduated ND filter stacked with a 2-stop hard filter, and its histogram.*

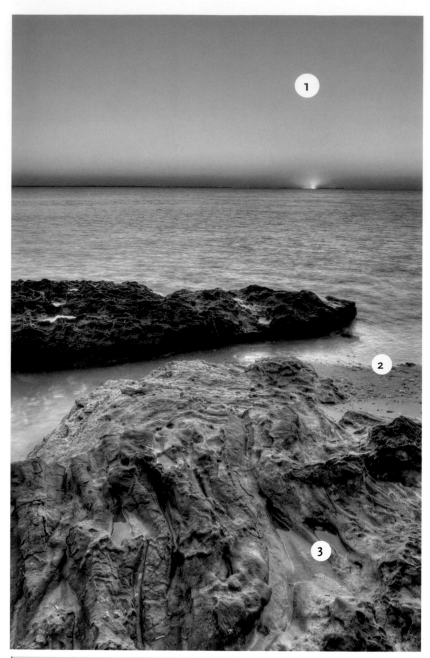

the dynamic range of the scene. It looks realistic, with proper tonal gradation, though foreground details are not quite as pronounced as in the HDR image. The third image (left) is an HDR image created in Photomatix Pro. It is beautifully rendered, foreground details have good local contrast, and colors are full and vibrant. The image looks realistic, but looking at the histogram, we can see that a reversal in the luminosity of the scene has occurred.

Recall our earlier discussion about HDR images portraying scenes more like our eyes see them. Well, this is certainly more true in some cases than in others. Local tone mapping operators and image compression during tone mapping can cause reversals in tonal relationships. The very characteristic that makes an image look impressive can also make it look unrealistic.

## Graduated ND Filters: Pros and Cons

### Pros

- Don't use up extra space on your memory card

- Quick results without a lot of post processing

- Gradation of light to dark isn't violated in most cases

- Tend to give realistic results; local contrast is maintained

- Able to capture motion, although shutter speeds are slower

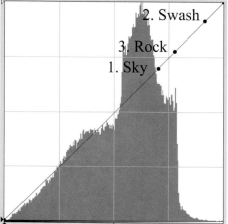

*Here is the HDR rendition of the scene (comprised of five images taken at 1EV spacing), and its histogram.*

## Cons

- Difficult to handle and install; scratch easily; dirt and moisture is a problem

- Need to carry a variety of filters for changing dynamic range

- Lens flare is common due to additional filter in front of the lens

- Hard edge can be visible in the final image Tends not to work well with irregular horizons, especially trees or buildings jutting into sky

- Can't use a lens hood

- Wide-angle lenses can vignette; not usable with fish-eye lenses

- Setup time can be longer than HDR photography

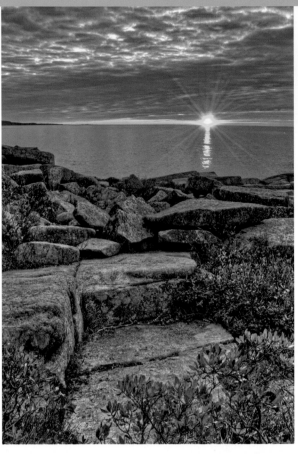

*I made this HDR image from five exposures taken at 1EV spacing, plus one additional exposure at − 3EV.*

# HDR Photography: Pros and Cons

### Pros

- Usage not dependent on scene composition; works well with irregular horizons

- No front filter to cause flare

- Bracketing is easy for capturinge large variations in dynamic range

- Unlimited focal lengths apply, even fish eye

### Cons

- Not good for subjects that are moving

- Uses more memory

- More computer processing time

- Tone mapping results can be unrealistic

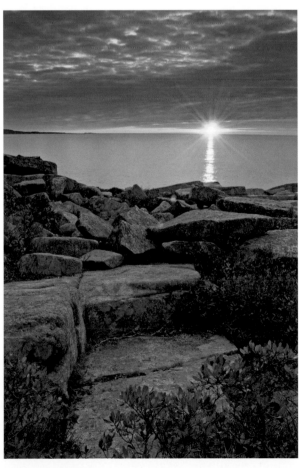

*To create this image, a 3-stop soft and 2-stop hard graduated ND filter were stacked in front of the lens. Notice that the lens flare caused by the ND filters is not present in the HDR image above.*

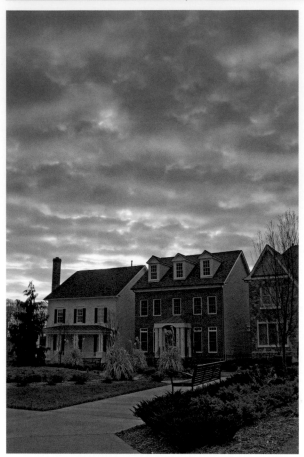

*This image was created with a 3-stop soft graduated ND filter.*

The 3-stop soft graduated ND filter was not able to control the local area of brightness just above the roof in the image at left, resulting in blown pixels. The HDR image (below) has good control of the sky in the same area, but don't get swept away by the "improved" color of the HDR image. A simple hue/saturation adjustment is all that's needed for the graduated ND image to be up to par color-wise with the HDR image, and in this case is considered a less important factor for comparison. A more important factor is the improved noise control and shadow detail in the HDR image. The bush in the foreground and tree on the left side show the HDR rendition to be superior in detail and noise control.

*This is an HDR image I created by merging five images at 1EV spacing in FDRTools, and tone mapping using the Compressor operator.*

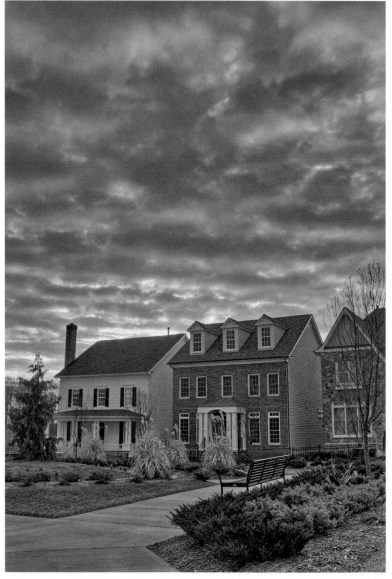

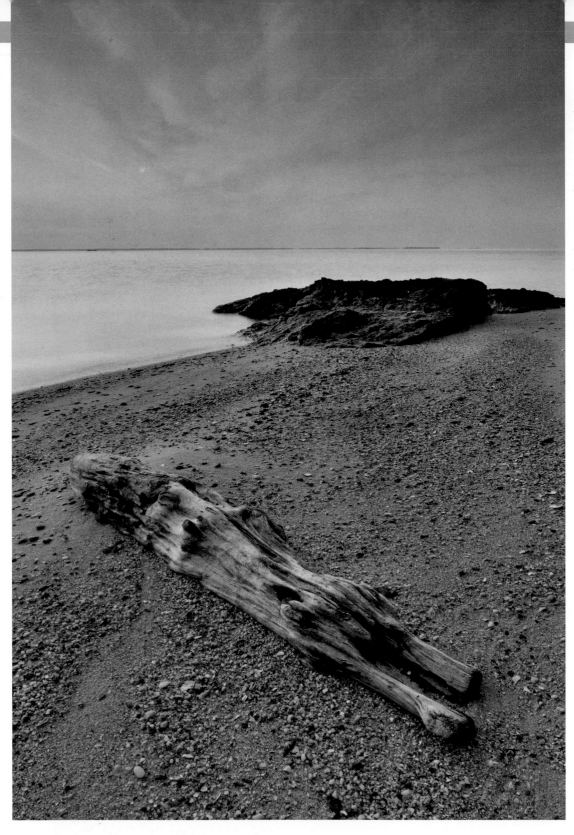

*I shot this scene with a 3-stop soft graduated ND filter, then tone mapped it using Photomatix Pro's Details Enhancer operator. I kept the Strength setting low (32), set Light Smoothing to Medium, and maximized the Black and White Points. This resulted in an image with little grain, open shadows, and sufficient contrast.*

## Single Image Tone Mapping of Graduated ND Filter Images

If you prefer the graduated ND filter and it fits your style of shooting, then consider tone mapping single graduated ND filter images. As long as you capture the full dynamic range of the scene, single image tone mapping offers a short cut alternative to HDR photography. Additionally, if you have archived images taken with graduated ND filters, you can breathe new life into them through tone mapping.

8

# ADVANCED IMAGE ANALYSIS

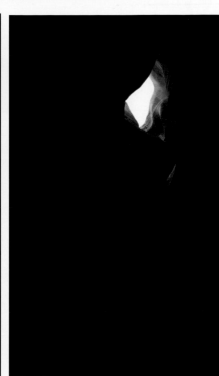

# Isolated Regions of Extreme Brightness

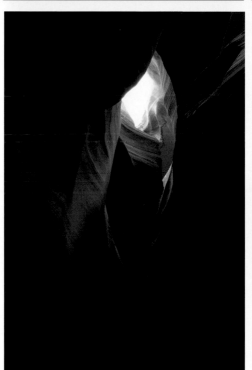

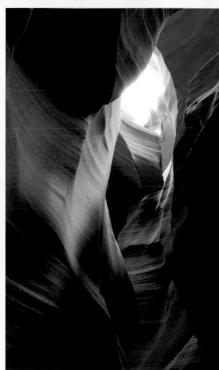

A ny scene that has small, isolated regions of brightness sets the stage for high contrast and can present problems when using matrix or zone metering. The camera will either ignore the bright area or place little emphasis on it while worrying about the other 98% of the image. Even with a bracketing of –2EV, the bright area can remain overexposed and lack color and detail in the final HDR image. The solution is to spot meter the bright area, obtain proper exposure then follow with a 2EV incremental increase in exposure values until the shadows are properly exposed.

*To capture ample exposures of this scene to create an HDR image, I spot metered the opening to the blue sky and incrementally increased exposure for a total of five images at 2EV spacing.*

1. Spot meter the bright area and set exposure using Manual exposure mode.

2. Compose the image.

3. Add +2EV to each additional exposure until the shadows are properly exposed.

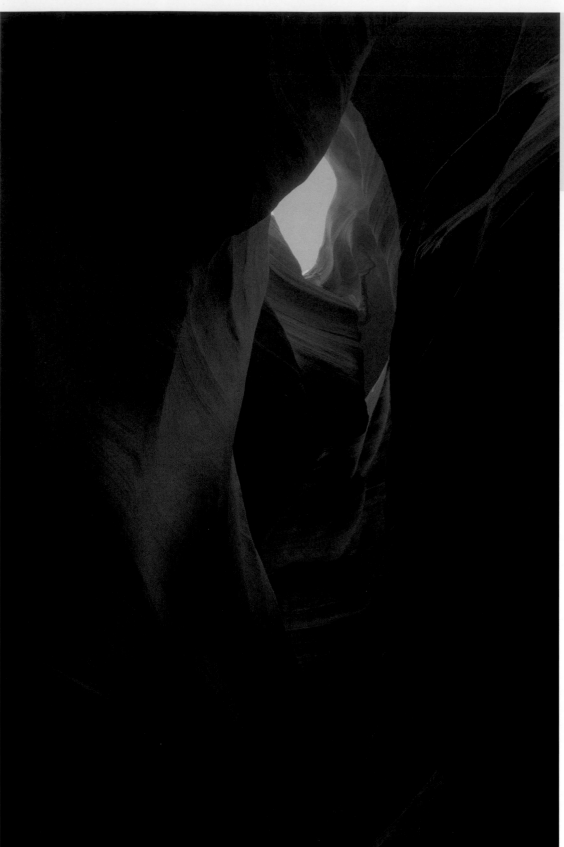

Photomatix Pro – Tone Compress
(used for preservation of shadow

Brightness: 0

Tonal Range Compression: 5

Contrast Adaptation: -1

White Point: 0.00%

Black Point: 0.300%

*Slot Canyon, Arizona: Here is the final merged and tone mapped HDR image.*

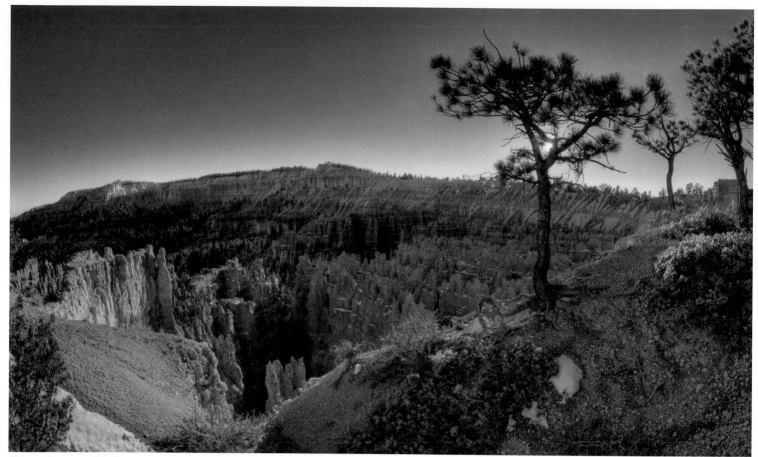

*Bryce Canyon, Utah*

# Including the Sun

The Bryce Canyon, Utah scene (above) had a dynamic range of 15EV when measured from the blue sky above to the dark shadows below. This is a unique condition, placing it above the dynamic range of most landscape scenes. (Scenes that include the sun can have an even higher dynamic range, but overexposure of the sun's disc is an accepted practice.)

Including the sun in your composition is asking for one thing: trouble. When the sun is unfiltered by clouds and atmosphere, problems such as lens flare and exposure become real issues. However, HDR photography can correct for the exposure problems if the bracketing range is sufficient. Remember that the scene is high contrast and will require additional exposures to capture the sky color and the shadow detail. Shoot an EV range of at least –3 to +3EV, then add a plus or minus exposure to guarantee full capture of the scene's dynamic range.

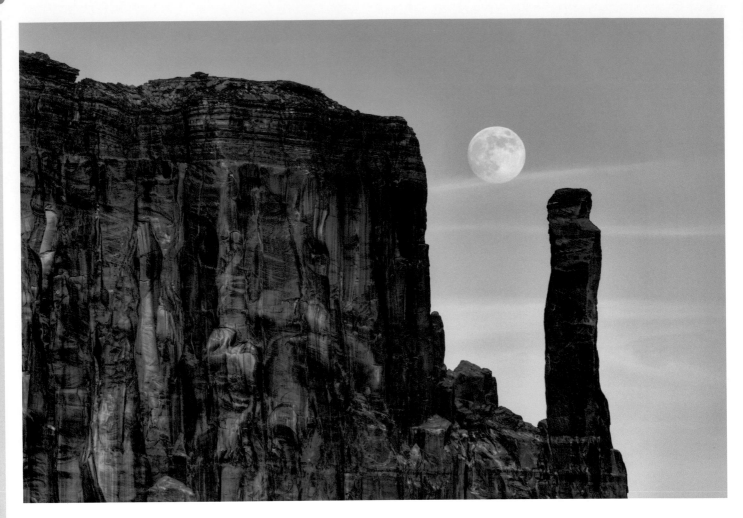

# HDR and the Moon

Lens flare is unavoidable when the sun is in the shot, but there are ways to minimize it. The first step is to use a lens with fewer elements. Fixed focal lengths are best, telephoto zooms are worst, and in all cases, avoid adding filters to the front of the lens and always use a lens hood. If you choose to compose with the sun off to the side, a lens hood is useful, but you can also use your hand to shade the front lens element. People will think you are waving at them, so be sure to wave back. If the sun is in your composition, try to clip it with an object in the foreground. It will dramatically reduce the chance of flare.

One of the challenges when the moon is included in landscape photography is keeping the luminosity of the moon within the dynamic range of the scene. Long exposures that are metered for the landscape often result in an overexposed moon that appears as a bland white circle. This can be prevented by simply being aware of the changing light conditions and shooting during a time of balanced luminosity between the land and the moon.

The following example takes place during the setting sun and a full moon rise, although the same techniques can be applied for the moon in its other phases. During the setting sun, the luminosity of the landscape continually decreases while the luminosity of the moon

stays the same (within reason). To properly expose for the moon and the land, the ideal approach would be to shoot during a time when the dynamic range of the scene is 6EV or less. This will allow a single shot with reasonable exposure of both landscape and moon to act as the base 0EV exposure.

As the landscape becomes darker and the dynamic range exceeds 6EV, an HDR image set is a viable option, provided a few conditions are met. When shooting an HDR image set, if several seconds pass during the bracketing, ghosting of the moon will become an issue in the merged image, so prepare to shoot the image set as quickly as possible. An easy workflow is to shoot in continuous AEB mode, with matrix metering, and bracket your exposures as you normally would.

A second option—the one I prefer because it ensures proper exposure of the moon—is to change the camera settings to spot metering and Manual exposure mode. Spot meter the moon, set the exposure, take the first image, then increase exposure for each image of the set by 1EV. Take three to five images. It can be an easy method, but it will require changing from the popular camera set up of matrix metering and using AEB. Also, this method requires fast-moving, nimble fingers that can change settings without moving the camera position, so be ready. The HDR image on page 164 was taken using this technique and consists of three images at 1EV spacing.

If you spot meter the moon, the exposure will vary depending on atmospheric conditions. When the moon is high above the horizon, 1/125 second at f/8 and ISO 100 is typical. However, full moon rise is 1/15 second at f/8 and ISO 100 due to the greater amount of atmosphere the light has to pass through.

# Can I Have Shadows and HDR?

Yes, with the proper tone mapping operator, HDR images can be rendered with dark shadows. Additionally, the subtle details in the shadows will have less noise than would be present in a single image rendition of the scene. Photomatix Pro software's Tone Compressor operator is a global operator that can tone map an HDR image to retain shadows and still offer the benefits of low noise. As an alternative to Tone Compressor, Details Enhancer has Shadows Clipping and Black Clipping, which can create up to 5% black pixels. The options aren't as versatile as those in Tone Compressor, but they will create a small amount of black pixels in the image.

*Here is a single shot of Slot Canyon, Arizona, and a close up of the shadow areas.*

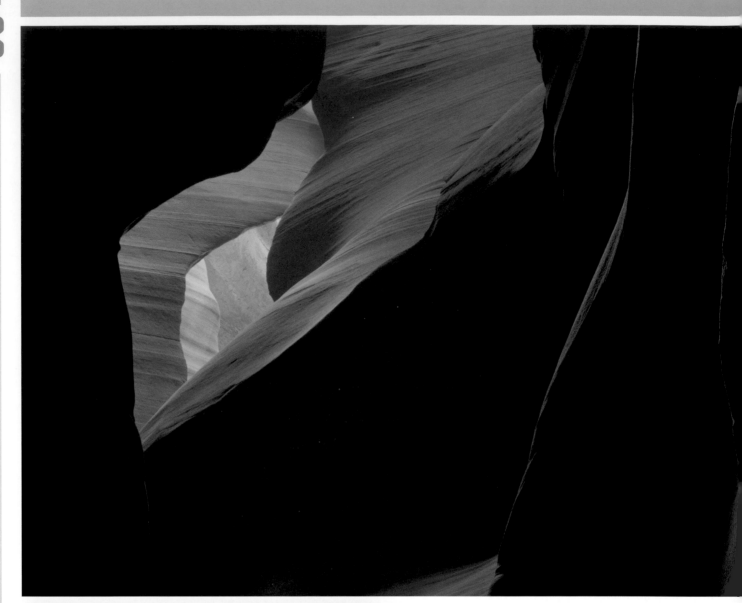

*This is the HDR rendition of the Slot Canyon, Arizona scene on page 163, and a close up the the shadow areas.*

The image taken in Slot Canyon, Arizona (above) shows that HDR images can have well-developed dark shadows. The added benefit with HDR is dark, well-detailed regions that are noise free. I used the Contrast Adaptation slider in Photomatix Pro's Tone Compressor operator to control shadow detail. A quick glance at the single image and it looks similar to the HDR image, but upon close inspection of the shadows (left), it's clear that the HDR image has better details.

# Macro and Flowers

Is it worth shooting several images and merging to HDR? It depends on the look you're after as the artist and whether a single image can accomplish that look. Just keep in mind that an HDR image has better exposed shadows and highlights and controls noise better than the single image. Shooting HDR macro in overcast light may not be substantially better than the single image, but a flower in direct sunlight can be improved with HDR.

The frame around the rose in the images at the right was created by pushing the lens into a vase of flowers and shooting through to another vase about three feet away. The colors in the HDR image (top) flow gently from one to another in this dreamy low-contrast scene. Conversely, the single image (bottom) has much greater contrast, which inherently places limitations on any Levels and Curves adjustments. The better image, of course, is a matter of opinion, but the fact remains that the HDR image has greater flexibility in compression or expansion of the tonal range.

I merged the image in Artizen HDR from three source images taken at 2EV spacing. The tone mapping operator, Schlick, was adjusted for high strength to maximizes compression of the image. In Photomatix Pro, the addition of Micro-smoothing can also create a soft palette of color and contrast, which would compliment this image.

*This is an HDR rendition of the rose.*

*Here is a single image of the rose.*

# HDR and Snow

Last time I checked, snow was white. At least it's supposed to be in our pictures, but it quickly turns gray if you get carried away with pixel compression. The algorithm sees white and says "Uh-oh. Better make this gray." And the funny thing is that trying to make it white again using Levels in Photoshop will most likely clip something other than the snow, so that approach won't solve the problem. The solution is to use a global operator like Tone Compressor, or a local operator like Details Enhancer with minimal compression and Highlights Smoothing. If you need to use high compression for an effect in another part of the picture and the snow turns gray, consider follow-up processing in Photoshop with a single exposure placed over the HDR image and blended using a Layers Mask (see pages 88-89).

*A global operator is able to render white much better than a local operator. I used Photomatix Pro's Tone Compressor operator to maintain the realism in this scene.*

# Black-and-White HDR Photography

HDR Photography is not just for color work. I created the image at right—taken in Acadia National Park at Jordan Pond—in Photomatix Pro by merging five images taken at 1EV spacing. I tone mapped the merged HDR file using Details Enhancer, then moved the Color Saturation slider to zero. An alternative to converting to black and white in the HDR program is to complete the tone mapping in color then later convert to black and white using another program. Advantages to black-and-white HDR photography include less noticeable halos, chromatic aberration is less visible along edges, and color noise becomes monochromatic, giving a creative textured feel to the image instead of detracting from it.

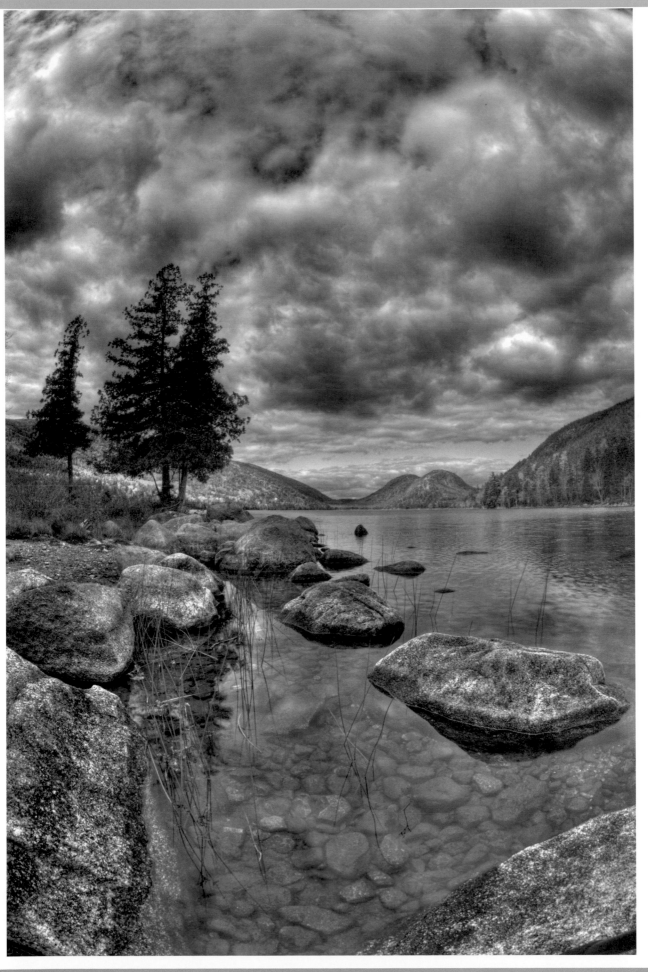

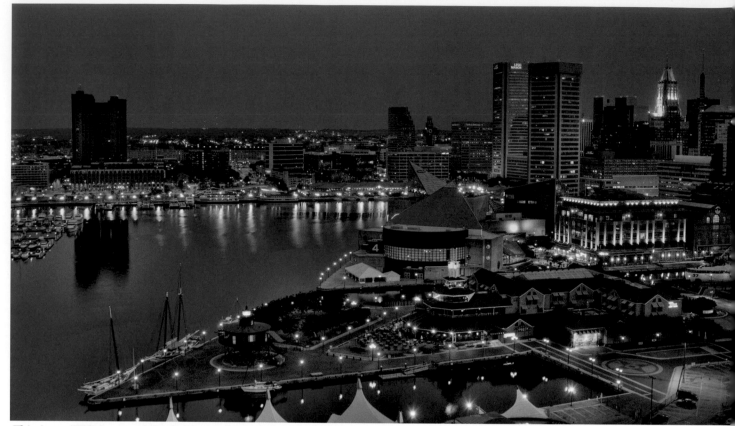

*This is an HDR image of the Baltimore Inner Harbor just before sunrise. I used four images, taken at +2EV, 0EV, -2EV and +3EV.*

*For this image, I activated the in-camera noise reduction feature and used the bulb setting with a cable release during the entire image set. It took about four minutes to complete, with shutter speeds of 4 seconds (–2EV), 15 seconds (0EV), 30 seconds (+1EV), and 60 seconds (+2EV).*

# Night and Low Light HDR Photography

HDR Photography at night offers the primary benefit of noise reduction and better color accuracy in low light. Along city streets, the dynamic range can be high, with bright light sources and nearby shadows. Although blown pixels in the streetlamps are not so bad, noise in the shadows can ruin the image. It's advisable to take an extra overexposed image or two to capture more shadow detail.

What about low light situations where the overexposed image requires a longer shutter speed than your camera will allow? That is certainly possible. Let's take this low light scene in the canyon (left). The camera's metering calls for f/11 at 15 seconds; one stop

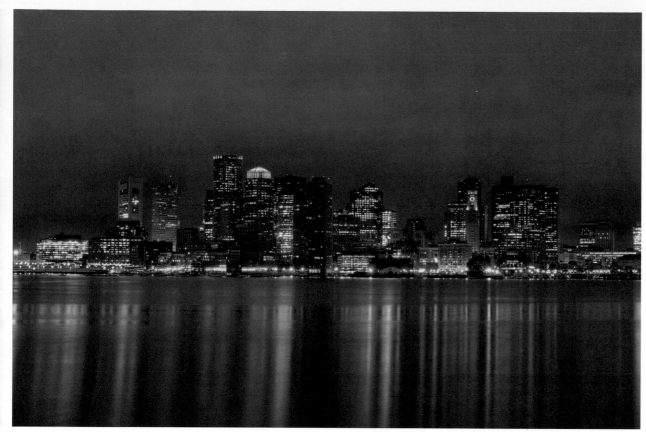

*Night photography is best done when it's not quite night. Powerful images can be taken one hour after sunset and one hour before sunrise when subtle skylight matches man-made light in brightness.*

over will be 30 seconds and two stops over will be 60 seconds. However, the maximum shutter speed for most D-SLRs is 30 seconds. If the camera is in AEB mode, it will ignore the 60 seconds and will simply duplicate the 30-second exposure. Check your camera's maximum shutter duration and, if needed, use the bulb setting.

In low light, a tripod is a must-have, and a cable release—preferably with built-in timer—is advisable. Here's the rule for using the bulb setting: If your metered exposure is around 10 seconds, then the +2EV exposure is 40 seconds, which may not be an option with your camera. If this is the case, switch to bulb for the entire image set. Use it for all the exposures, even the ones below 30 seconds. Just enter the shutter speed into your cable timer (if available) and the entire image set can be taken hands-free. Otherwise, you'll find yourself fiddling with the buttons and possibly moving the camera trying to make the switch to bulb.

Moving headlights at night can become a problem during the HDR merging process. The image can become patchy as blown pixels from the bright headlights are discarded for "quality" pixels in another. The result is a dark patch surrounded by the glow of the light. This problem can also occur with water ripples, where a reflection in one image is not there in the next. Photomatix Pro has a feature called Ripples that is worth trying if you run into this issue. I prefer using Layers and Masks in Photoshop and blending one or several of the single exposures into the HDR image.

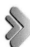

# Extreme Tone Mapping

Tone mapping has many sides to its personality. It can make an image ultra realistic, or it can take the same image and make it look painterly, surreal, outlandish, or even gaudy. The one part of tone mapping that's undeniable is that it's fun! Photomatix Pro Pro and Dynamic Photo-HDR are the best programs I've found for creating many different looks, and you can spend lots of time being creative.

The versatility in settings is not the end of it; you can even tone map an image a second time—double tone mapping! It's easy; simply apply tone mapping to the image as you normally would, click "OK." Then, open the same image in the tone mapping dialog and start tone mapping it a second time.

Photomatix Pro – Details Enhancer

Strength: 85

Color Saturation: 65

Light Smoothing: Medium

Luminosity: 0

Micro-contrast: 1

Micro-smoothing: 0

White Point: 2.975%

Black Point: 0.952%

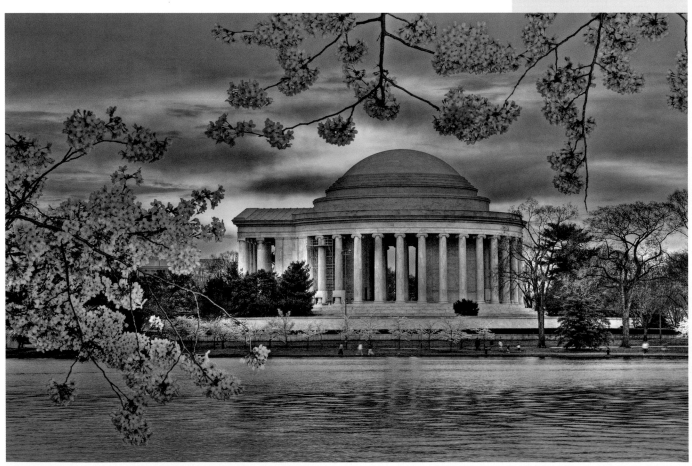

*To create this single tone mapped image, I used fill flash on the cherry blossoms when I took the shot, and tone mapped the image one time.*

Photomatix Pro – Details Enhancer

Strength: 100

Color Saturation: 68

Light Smoothing: Low

Luminosity: 1

Micro-contrast: 10

Micro-smoothing: 0

White Point: 0.020%

Black Point: 0.044%

*This old tow truck has seen better days. I tone mapped the HDR image once, then again with approximately the same settings.*

| ❊ First Tone Mapping Settings | ❊ Second Tone Mapping Settings |
|---|---|
| Photomatix Pro – Details Enhancer | Photomatix Pro – Details Enhancer |
| Strength: 100 | Strength: 75 |
| Color Saturation: 58 | Color Saturation: 40 |
| Light Smoothing: High | Light Smoothing: Very High |
| Luminosity: 0 | Luminosity: 0 |
| Micro-contrast: 10 | Micro-contrast: 5 |
| Micro-smoothing: 0 | Micro-smoothing: 2 |
| White Point: 0.092% | White Point: 0.092% |
| Black Point: 0.044% | Black Point: 0.044% |

*This is a low contrast scene; I used three images taken at 1EV spacing to create the HDR file, then tone mapped it, but a single tone mapped image would've worked just as well in this case. I chose to double tone map this image for added effect.*

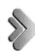

✻ **First Tone Mapping Settingså**

Photomatix Pro – Details Enhancer

Strength: 100

Color Saturation: 63

Light Smoothing: Very Low

Luminosity: 8

Micro-contrast: 10

Micro-smoothing: 0

White Point: 0.000%

Black Point: 0.000%

✻ **Second Tone Mapping Settings**

Photomatix Pro – Details Enhancer

Strength: 75

Color Saturation: 35

Light Smoothing: Very High

Luminosity: 8

Micro-contrast: 5

Micro-smoothing: 0

White Point: 0.000%

Black Point: 0.000%

*For images that don't include the sky, you can really push the limits of tone mapping for some interesting effects. For the first tone mapping, I set Light Smoothing to Very Low, and in the second I set it to Very High. The first pass looked horrible, but the second pass created a strong edge effect resulting in a highly dramatic image.*

Photomatix Pro – Details Enhancer

Strength: 85

Color Saturation: 70

Light Smoothing: High

Luminosity: 0

Micro-contrast: 10

Micro-smoothing: 2

White Point: 1.222%

Black Point: 1.270%

*I applied the same settings twice for this tavern image, then I opened it in Photoshop along with the −1EV exposure. To correct the strong halo in the blue sky, I blended the sky from the −1EV image into the tone mapped image using a Layers Mask. Blue skies of uniform color are easily selected using the Magic Wand tool.*

*If you try double tone mapping with a scene that has a blue sky, count on having to blend in the sky from one of the single RAW images to avoid halos and ugly grain. This image was tone mapped using the same technique as the cathedral ceiling (left). To see more conservative tone mapping of this image, refer back to page 99.*

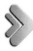

*Double tone mapping of the sand dollar in the surf added contrast and enhanced details.*

## HDR Portraits

HDR images with a person can be done if they are motionless for the entire image set. A seated pose or one where the person can lean steadily against something is always better than free standing. Also, remind them to look at the same point during the entire image set, as even slight eye movement will show. In addition, consider shooting a single image and tone mapping it, especially if the subject is moving. Try to overexpose as much as possible to minimize noise. Tone mapping a single image will enhance the noise.

HDR photography of people can go either way. At times, the HDR look can be compelling, while other times it can be just plain odd. It's not always a matter of changing the tone mapping settings, but often what they are wearing, skin tones, eye color, lighting, and surroundings that decide the outcome.

# index